Seeing Silicon Valley

The University of Chicago Press / Chicago / London

Seeing Silicon Valley

Life inside a Fraying America

Photographs and Stories — **Mary Beth Meehan** *Essay* — **Fred Turner**

The University of Chicago Press, Chicago, 60637
The University of Chicago Press, Ltd., London

For more information, contact
The University of Chicago Press,
1427 E. 60th St., Chicago, IL 60637.

Published 2021
Printed in Italy

30 29 28 27 26 25 24 23 22 21 2 3 4 5

ISBN-13: 978-0-226-78648-3 (paper)
ISBN-13: 978-0-226-78651-3 (e-book)
DOI: https://doi.org/10.7208/chicago
/9780226786513.001.0001

First published in French as *Visages de la
Silicon Valley* by C&F Éditions, 2018.

All images by Mary Beth Meehan

Frontispiece: *Getting dressed for
a workers' rights rally, San Jose*.

Book design by Lucinda Hitchcock
Typefaces used: Greta Text by Peter Bilak;
Fakt by Thomas Thiemich; Dala Floda
by Paul Barnes

Library of Congress Control Number:
2020039791

This book is printed on acid-free paper.

Contents

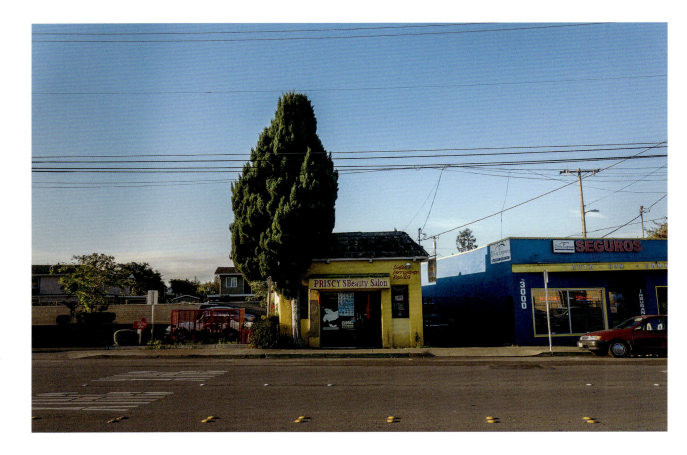

Middlefield Road, Redwood City

The Valley on the Hill — *Fred Turner*

For the last fifty years, Silicon Valley has been shrouded in myth. Its laptops and cell phones have glittered with the promise of a glorious technology-enabled future. Its entrepreneurs and venture capitalists have seemed to stride the heights of creativity and individualism. Steve Jobs, Mark Zuckerberg, Apple, Google, Facebook, Tesla—for years, these names alone have conjured visions of extraordinary wealth, egalitarian opportunity, and universal access to the products of America's most cutting-edge industries.

Today that mythology is beginning to dissolve, but only just. People around the world continue to imagine Silicon Valley as a kind of American utopia. Like the Pilgrims who sailed across the Atlantic in the 1600s, technologists and entrepreneurs still travel to the valley from around the globe. They may fly or drive, but their sense of mission and their search for profits is as old as America itself. In 1630, Puritan minister John Winthrop famously addressed his flock as they sailed toward the New World: "We must consider that we shall be as a city upon a hill," he told them. "The eyes of all people are upon us."

He could as easily have been speaking to a plane-load of engineers landing in San Francisco.

Because the valley still conjures up such visions, we need to try to see it as it is. Who lives here, and how? Silicon Valley has long been a shining example for those who dream of a society built around individual initiative and enabling technologies. But what does it feel like to live in such a world? What kind of society does the relentless pursuit of technological innovation and wealth produce? And what kind of future does it suggest for the rest of us?

Some of the answers lie hidden in the land. Unless you live here or visit, chances are you won't know the green hills that run up the ocean side of the San Francisco Peninsula, nor will you recognize the flatlands that melt into the mud of the San Francisco Bay. What we call Silicon Valley stretches between the bay and the hills from the city of San Jose in the south to San Francisco in the north. Until Spanish missionaries arrived in the late eighteenth century, it was inhabited primarily by native Ohlone peoples, tens of thousands of whom were ultimately massacred and enslaved.

If you look down on the valley from the air today, you'll see none of that history. Dense green forests run down the hills into golden fields; block after block of suburban housing packs the flatlands; cars and trucks stream north and south, east and west across the valley. Water

stretches out from the shore first in the shallow multicolored squares produced by salt manufacturing and then into the slate gray, wind-blown center of the bay. Long-legged willets peck for mollusks along the waterline. And flocks of sandpipers whistle through the air. Thanks to open space preservation, the hills that rim the valley are still wild enough to host mountain lions. Walk through any of the dozens of towns that fill the valley floor and you might see eucalyptus trees or spiked orange blooms called birds of paradise growing at the edges of lawns.

What you won't see are the poisons flowing underground. From the early 1960s to the early 1980s, local companies manufactured the computing hardware and silicon chips that gave the valley its name. We know now that they used highly toxic chemicals in the process and often dumped them onto the land around their plants. Those chemicals caused miscarriages and birth defects at the time and linger in the soil today. In some neighborhoods, underground plumes of solvents threaten drinking water. And as they evaporate, they send toxic gases into the homes above ground. Santa Clara County, which covers the southern half of the valley, has the highest number of Superfund sites of any county in America: twenty-three. Superfund sites are places that the Environmental Protection Agency has marked as among the most polluted in the United States and the most in need of immediate, government-funded cleanup. Journalists have identified more than five hundred other patches of contaminated land that were not quite polluted enough to make the Superfund list.[1]

Today valley firms concentrate on software development, biotech research, and product design. Most computer technology manufacturers shipped production overseas starting in the 1980s. The toxins of earlier eras are still in use but out of sight: offshoring hides them somewhere in Asia, far from American eyes. Likewise, the ground itself covers over the price of technology development. Without a map of Superfund sites in the valley or a historical atlas that marks the location of long-gone manufacturers, it's impossible to know what's under your feet. And without that knowledge, it's all too easy to imagine the bright sunshine and green hills that frame the valley as signs that technology development has no impact on the natural world.

The Silicon Valley we know got its start in the wake of World War II, when the dean of Stanford's School of Engineering, Frederick Terman, began to lure technologists and engineers from around the country to the edge of campus. Fueled by Defense Department dollars

and the can-do ethos of Cold War engineering, companies like Fairchild Semiconductor transformed the region into a hive of computer manufacturing, software development, and collective entrepreneurship. Companies like Apple and Google grew up in their wake.

Journalists and marketers soon knit the new industries into the fabric of American myth. They depicted engineers as explorers, laboring in their garages or tinkering in their bedrooms until they conquered new frontiers. They offered us computers and cell phones with the promise that they would make us heroes too. With these devices in hand, they claimed, we could leave the ordinary, workaday world behind and step out onto an electronic frontier, where none of the old rules applied.

At the same time, in Silicon Valley, the technologists they celebrated were creating a culture rooted in some of America's earliest ideals. Though Northern California sits three thousand miles and four hundred years away from colonial New England, the Protestant ethic that animated the seventeenth-century Pilgrims suffuses its high-tech industries. The Pilgrims arrived in the Americas believing that God had already decided who among them would go to heaven and who would not. They also believed that if God loved someone enough to bring them into heaven, He would want them to prosper on this earth. Day after day the Pilgrims worked to make themselves wealthy and so accrue evidence of their likely salvation. Day after day, they watched one another as they imagined God watched them all, to see who among them would be saved.

Today, they would scan the media. On television, in magazine profiles, in an endless stream of TED talks, the valley's engineers appear to be not quite of this earth. Often young, socially awkward, barely at home in their bodies, they seem exquisitely tuned to the celestial frequencies of technological innovation. Journalists recount their professional achievements as a series of spiritual tests. They tell us how the

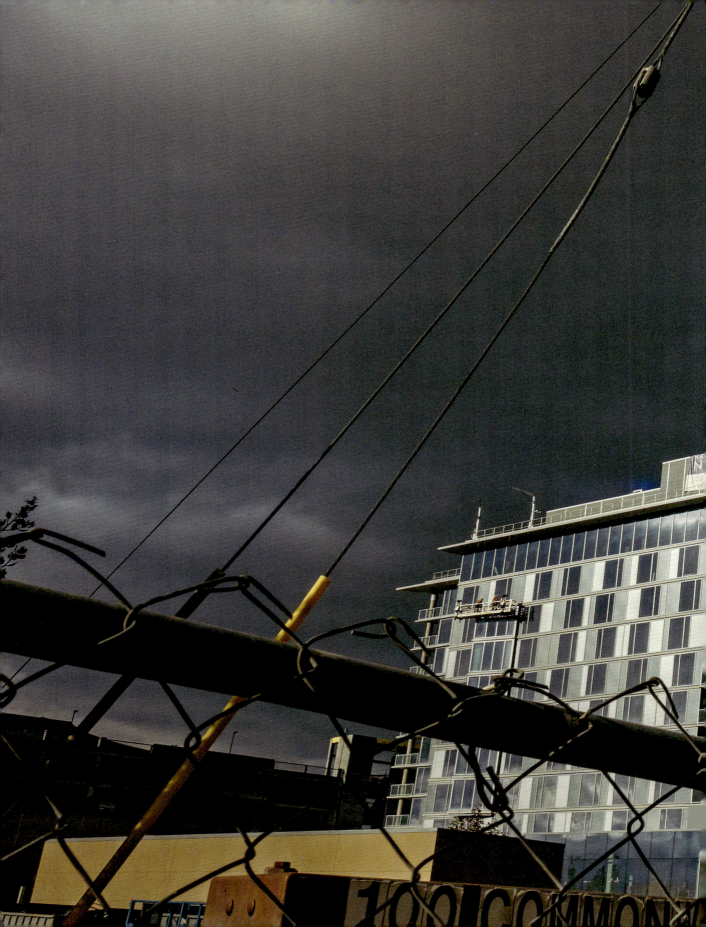

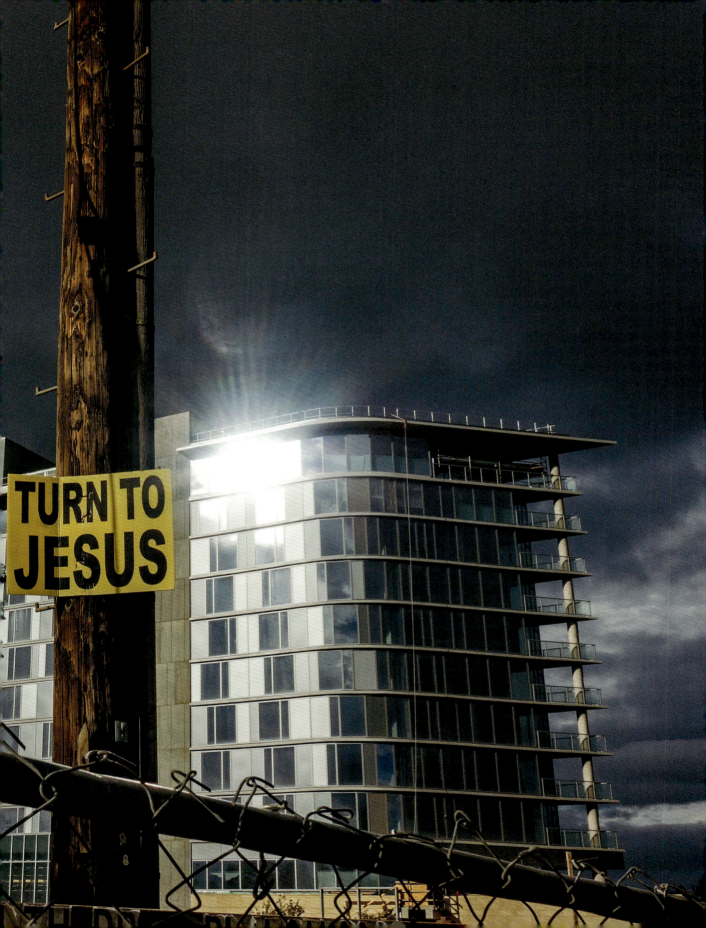

(previous spread) *New construction, Highway 101*

winners in Silicon Valley failed fast and bounced back; how they stood tall under the withering inquiries of venture capitalists; how they aced Google's famously difficult hiring interviews. In such tales, the landscape of Northern California becomes a new stage for the drama of salvation, and every company's profit and loss statement an accounting of spiritual worth.

This way of depicting Silicon Valley obscures the persistence of a darker side of America's colonial past. Even as they tended to one another, many Pilgrims regarded the natives who surrounded them as demons in human flesh. They feared the longings of their own flesh too—their hungers for intimacy, for food, for sleep. To build a proper community they believed they had to turn their eyes upward, forget their bodies, and devote their attentions to their spiritual mission. Only by unseeing their own humanity and that of the native peoples who greeted them could the Pilgrims think of themselves as uniquely favored by God.

Such denials of the body fuel the development of new technologies today. The leading firms of Silicon Valley make their money by transforming our lives into patterns of data, bits of electricity that spin off from what we do and rise up into a cloud of servers around the world. These patterns remain invisible to most of us—the algorithms that produce them are, after all, trade secrets. But the "big data" on which our digital systems depend are nothing more than our own history, aggregated and repurposed. As they listen to our conversations or record our faces, our Amazon Echoes and Apple iPhones capture everything we do, including the patterns of our prejudice, and return it to us as suggestions, nudges, recommendations.

By turning our attention toward themselves and their signals, such devices teach us to look away from one another. They also teach us to imagine that tiny machines, all on their own, can do magical things, and so not to think about the people who build our computers, monitor our online conversations, and tear apart our computers after we've thrown them away.

In Silicon Valley, it has become particularly hard for us to notice anyone other than the region's elect. Elon Musk could not have built Tesla without the fleshy, sweaty labor of thousands of riveters, packagers, and drivers. The founders of Google could have done nothing without legions of coders, cooks, janitors, and day-care workers. And none of those workers could have come together without the laborers who build and maintain the bridges across the bay, the highways across the valley, and the houses, shops, and factories on which life in the valley depends.

The workers of Silicon Valley rarely look like the men idealized in its lore. Their bodies are more varied, sometimes heavier, sometimes older, often darker skinned. Many were born far from California. The region has enjoyed steady migration from overseas for decades; in the last five years alone, close to one hundred thousand international immigrants have taken up residence in Santa Clara and San Mateo Counties.[2] Parts of Silicon Valley resemble the cosmopolitan precincts of Manhattan and Los Angeles. A mosque bumps up against a Jewish Community Center in Palo Alto. Filipino, Afghan, Mexican, Vietnamese, and Punjabi restaurants jostle for space within a single long block in the town of Mountain View. In the fall, some homeowners decorate for Halloween, while their next-door neighbors hang lights for the Indian festival of Diwali. In 2019, 38 percent of the valley's population was born outside the United States and more than half of the valley's residents spoke a language other than English at home.

Since the Great Recession of 2008, and especially in the last few years, Silicon Valley's economy has been on a tear. Google, Facebook, and Apple have all dramatically expanded their headquarters, and other firms have followed at speed. Since 2015, more than thirty million square feet of commercial real estate has been created—more than all that was developed in the preceding decade.[3] In 2019, the valley spawned nearly thirty thousand new jobs. In 2018, valley innovators were granted a staggering 18,455 patents—down just slightly from the approximately 19,000 of the year before. The concentration of wealth in the region is correspondingly awe inspiring. Seventy-four billionaires lived in the valley in 2018.[4] And the median household income of valley residents that year was $118,000—almost twice the national figure.[5]

These numbers are deceptive, though. Silicon Valley is not only one of the wealthiest regions in the United States. It is also one of the most unequal. People with a graduate or professional degree earn $93,000 a year more than people with less than a high school diploma, and the gap continues to widen. Newspapers around the world routinely note the valley's horrendous traffic and its stratospheric housing prices. Yet

they rarely point out that 7 percent of valley families live in poverty. In 2017, 14 percent of pregnant women lacked consistent access to what analysts call "nutritionally adequate" food.[6] Two years later, more than a third of all elementary, middle, and high school students in the valley were receiving free or reduced-cost meals.[7] And today, nearly 30 percent of valley households do not earn enough money to pay for food, housing, and other basic needs without government or private assistance—that is, to be self-sufficient. The picture becomes even more troubling when race is factored in. In 2019, nearly half of all African American households and 57 percent of Latino households lived below the standard of self-sufficiency. Less than one in five white households could say the same.[8]

In seventeenth-century New England, such disparities would have been unremarkable. Native Americans, Africans, Spanish Catholics— by definition, none could be members of Puritan society. Today, the lines of racial and economic inequality that divide Silicon Valley plague American life.[9] So too does the gulf between the many millions of dollars earned by the valley's executives and the more modest wages earned by their hourly workers and contract employees. For all its innovations, Silicon Valley remains in many ways a mirror of America itself.

In that sense, it really is a city on a hill for our time. And because it is, we need to look up from our screens, turn away from the dazzling streams of bits and bytes flowing through them, and look again at the people who inhabit it. The same inherited Puritan logic that has driven us to celebrate the market's elevation of men like Zuckerberg and Jobs has blinded us to the demands of community here and now. If we're going to meet those demands, in Silicon Valley and beyond, we're going to have to turn our eyes away from heaven and back to earth.

Notes

1. Zoë Schlanger, "Silicon Valley is home to more toxic Superfund sites than anywhere else in the country," *Quartz*, June 28, 2017, https://qz.com/1017181 /silicon-Valley-pollution-there-are-more-superfund -sites-in-santa-clara-than-any-other-us-county/.

2. Joint Venture Silicon Valley, *2020 Silicon Valley Index*, 11. Unless otherwise noted, all statistics in this essay have been drawn from this report.

3. Source data for these figures can be found in Joint Venture Silicon Valley, *2018 Silicon Valley Index*, 9; *2019 Silicon Valley Index*, 44; *2020 Silicon Valley Index*, 54.

4. Theodore Schleifer, "There are 143 tech billionaires around the world, and half of them live in Silicon Valley," *Recode*, May 19, 2018, https://www.recode .net/2018/5/19/17370288/silicon-valley-how-many -billionaires-start-up-tech-bay-area.

5. *2019 Silicon Valley Index*, 26. The median household income in the United States for 2018 was $61,937. See United States Census Bureau, "U.S. Median Household Income Up in 2018 from 2017," https:// www.census.gov/library/stories/2019/09/us-median -household-income-up-in-2018-from-2017.html. Accessed May 25, 2020.

6. *2018 Silicon Valley Index*, 9.

7. *2020 Silicon Valley Index*, 40.

8. The *Self-Sufficiency Standard for California* was developed by Dr. Diana Pearce at the University of Washington and can be accessed here: http://www .selfsufficiencystandard.org/. Poverty thresholds are set by the Census Bureau. For more on both metrics, see *2020 Silicon Valley Index*, 38.

9. For data on these divisions, see the Peterson report: https://www.pgpf.org/blog/2019/10/income-and -wealth-in-the-united-states-an-overview-of-data.

Photographs and Stories — *Mary Beth Meehan*

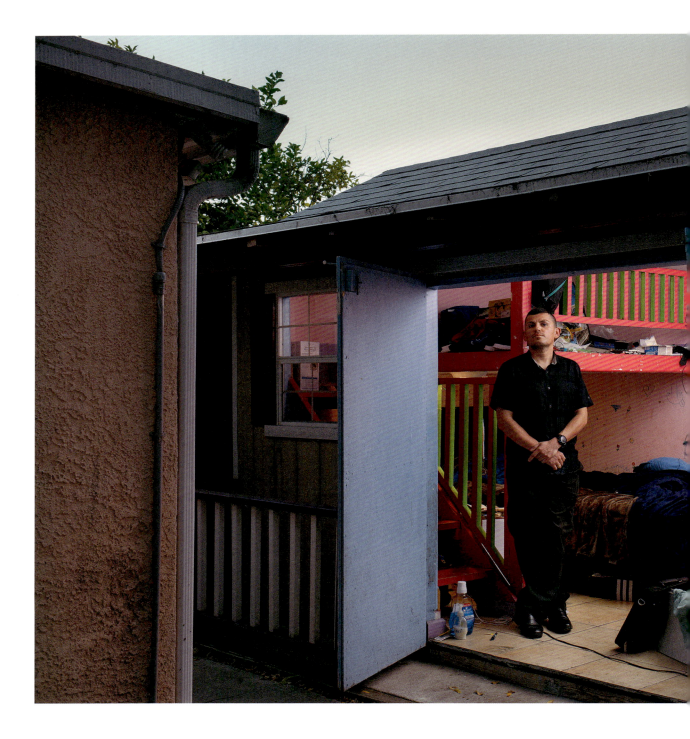

CRISTOBAL

Cristobal is a United States Army veteran. He served for seven years, including three years in the war in Iraq. He now works full-time as a contract security officer at Facebook.

Beginning at sunrise, Cristobal stands at a crosswalk on Hacker Way, guiding the traffic—employee buses arriving, executives in company cars, pedestrians looking down at their phones who need to cross safely. He earns $21 per hour, which doesn't afford him a home in Silicon Valley. So he lives in a shed in a backyard in Mountain View.

Cristobal has spent a lot of time thinking about his time in the army, about how he fought to defend the freedoms that allow a company like Facebook to flourish in this country. He has begun to organize with other service employees in the tech industry—cooks, custodians, security officers—to fight for better benefits, higher pay. He sees himself as part of an army of workers who are doing their best to support the big tech companies. But he doesn't see any of the wealth trickling down to them.

Vacant offices, Menlo Park

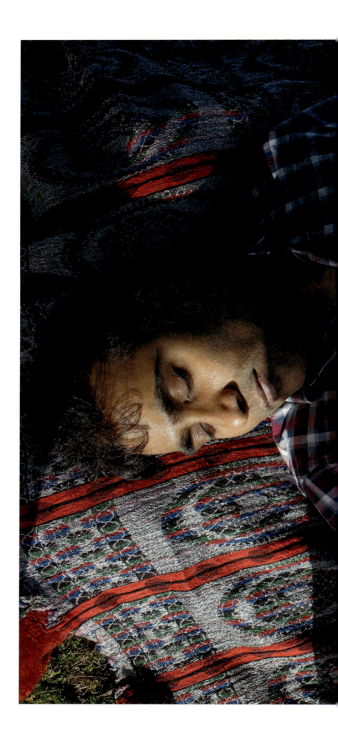

RAVI and GOUTHAMI

Between them, Ravi and Gouthami have multiple degrees—in biotechnology, computer science, chemistry, and statistics. After studying in India and working in Wisconsin and Texas, they have landed here, in the international center of technology, where they work in the pharmaceutical-technology industry. They rent an apartment in Foster City and attend a Hindu temple in Sunnyvale, where immigrants from India have been building a community since the early 1990s. Although the couple have worked hard to get here, and they make good money, they feel that a future in Silicon Valley eludes them—their one-bedroom apartment, for example, costs almost $3,000 a month. They could move somewhere less expensive, but, with the traffic, they'd spend hours each day commuting. They would like to stay, but they don't feel confident that they can save, invest, start a family. They're not sure what to do next.

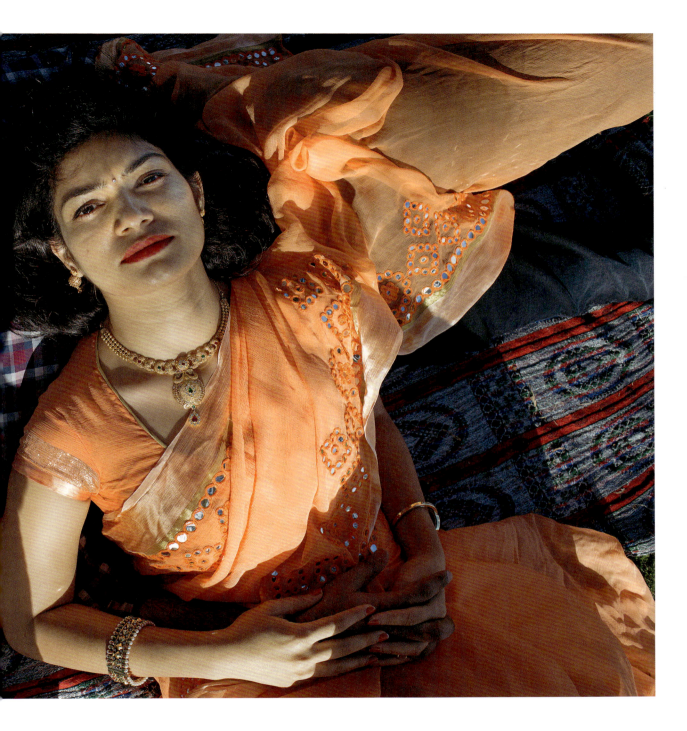

Off El Camino Real, Redwood City

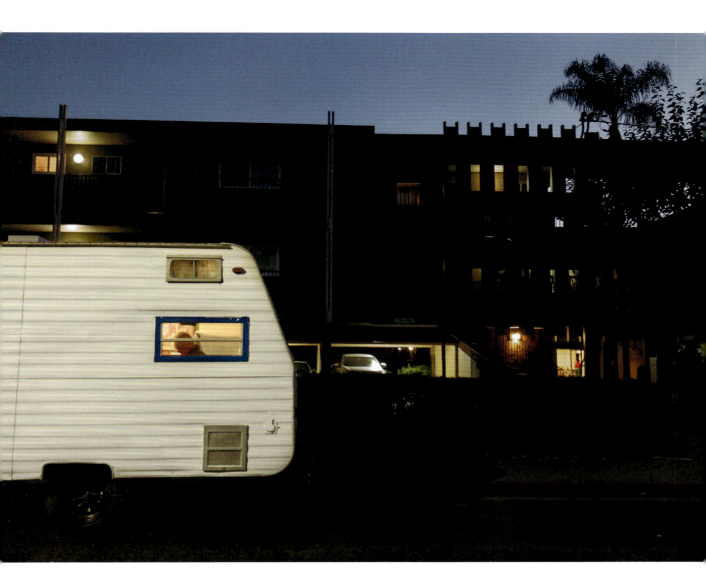

Victor's trailer, Mountain View

VICTOR USED TO LIVE IN AN APARTMENT NEAR GOOGLE BUT HAD TO LEAVE WHEN THE RENT GOT TOO HIGH.

VICTOR

Victor came to Silicon Valley from El Salvador more than twenty-five years ago. He lives in a small white trailer in Mountain View, a couple of miles from Google's campus. He used to live in an apartment nearby but had to leave when the rent got too high. His trailer is parked in a long line of trailers, some inhabited by others who've lost their homes. Victor doesn't have electricity or running water, but the custodians in his old apartment building remember him and sneak him in to bathe and wash his clothes.

Now in his 80s, he no longer works, but in his backpack he carries a jar of ointment. When someone has a twisted ankle or a stiff neck, he or she knocks on Victor's trailer door; "Don Victor," they call him. He sets out a chair for his neighbor to sit on and massages the sore spot until the pain passes.

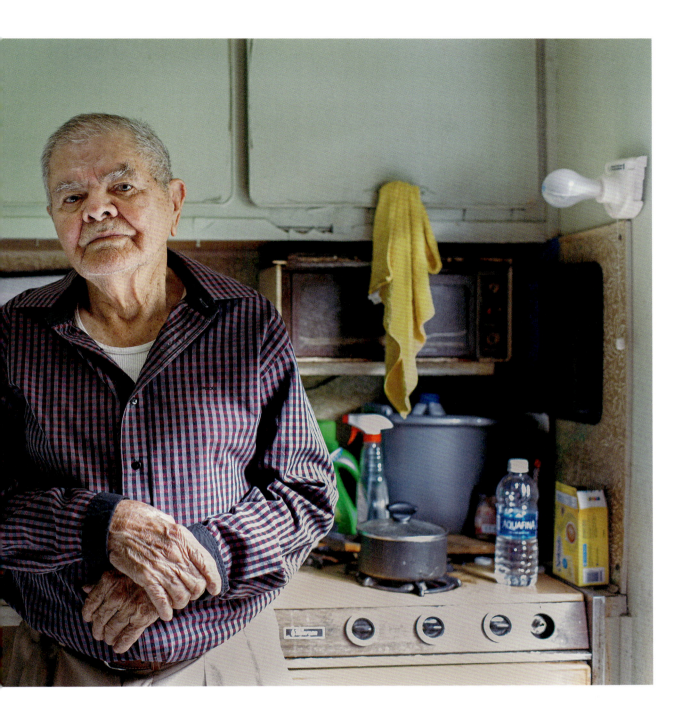

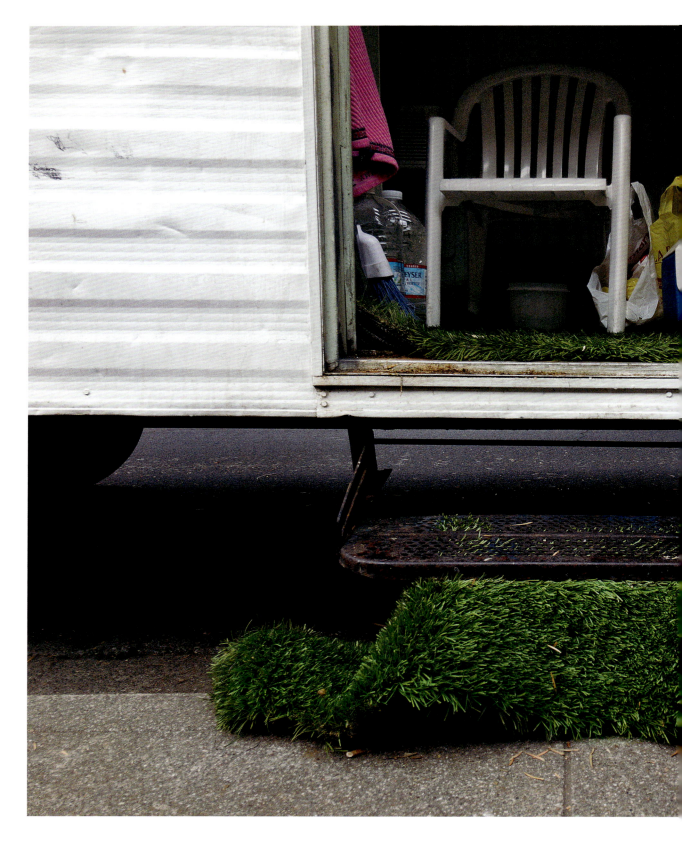

Victor's welcome mat, Mountain View

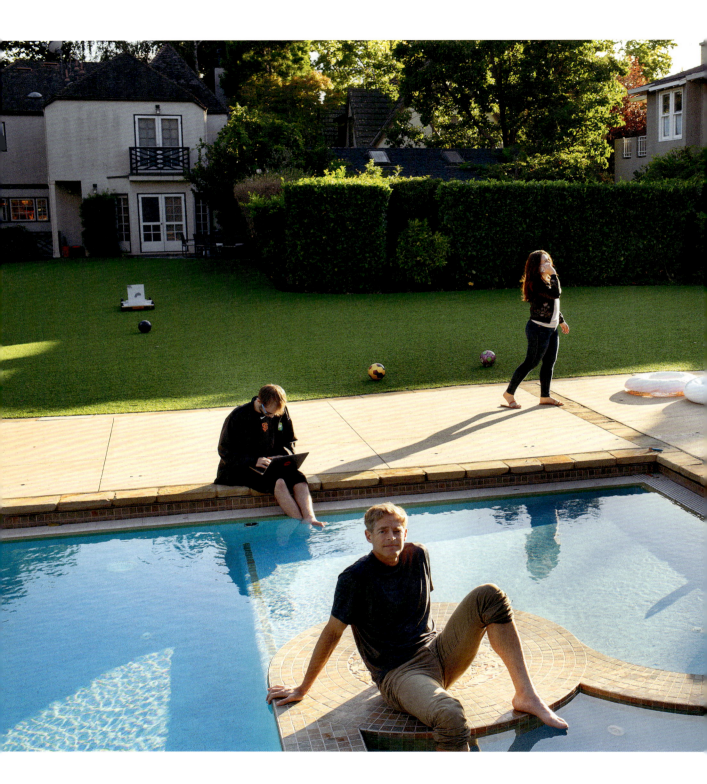

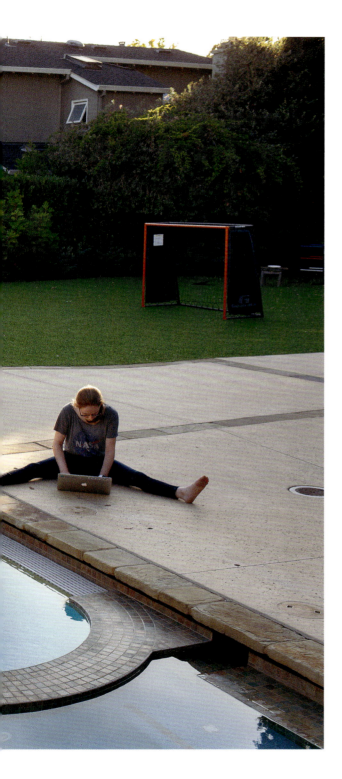

WARREN

In junior high, in Illinois, before he knew anyone else who had a personal computer, Warren got to play Lemonade Stand on his uncle Bob's Commodore PET. At thirteen, he attended a computer trade show in Chicago: "I didn't even know what I was looking at," he says. "But it was cool. It piqued my curiosity profoundly."

In high school, Warren sought out a friend who could teach him all the workings of computers. After he graduated as his school's valedictorian, Warren went to Stanford to study engineering and business. Then he became a venture capitalist, backing such fledgling firms as Skype, Hotmail, and Tesla (and turning down the founders of Theranos, one of Silicon Valley's legendary frauds).

Ten years ago, he says, "I did a very Silicon Valley thing": he called a few of his industry pals to launch Thuuz, a service that creates highlights of sporting events in real time. He runs the company out of a bungalow in Palo Alto, adjacent to his house—just a block away from the garage where Hewlett-Packard began.

Warren's company is small, and while he wants it to be successful, he doesn't strive to make it one of Silicon Valley's giants. "Many of those companies are huge because they are willing to cross some lines," he says—ethical, moral lines.

"Steve Jobs was irascible," he says, "Jobs was tough, Jobs was rude." But, says Warren, thanks to the iPhone, billions of people in India and China now have access to information. "I put Steve Jobs above that line and say, 'Yeah, he could have been a jerk, but he's above that line.'"

Warren feels differently about Facebook's Mark Zuckerberg. "He has broken some massive, massive rules," he says. "He is completely abusing his users." Facebook has "corrupted our election. They corrupted Brexit, over in Europe. They've destroyed minorities in Asia. . . . They are below the line, below the line. Absolutely, below the line."

"IF WE WANT TO ACHIEVE EXCELLENCE IN TECHNOLOGY, WHY CAN'T WE ACHIEVE EXCELLENCE IN BEING GOOD TO EACH OTHER?"

JUSTYNA

"I wanted to make something really good for the world," says Justyna. "This is when I was still idealistic."

Justyna left Poland to earn a PhD in engineering science in Germany and then came to the United States to do research at Harvard. In 2014, she led a team that won a White House competition, using existing technology to design an autonomous emergency-response system: robots, drones, and other self-driving vehicles would be sent into areas devastated by earthquakes or floods, saving many more lives than is currently possible. But she couldn't find the funding to build it. "No one's got a business model for it," she says. "No one's paying for it.... We're living in a capitalistic world. If you want to create something like emergency response, you first have to succeed financially in the capitalistic world, in order to have the investment to make. I had to learn that."

Since then, Justyna has been working on self-driving cars and lives in a mansion that she shares with other scientists in Cupertino. "I feel more established scientifically and technically now," she says. But, she continues, "twenty years ago, when I was young and still in Poland, everybody knew what the core values were, what was important: integrity, respect for other humans, taking care of each other, and being good to each other. Now, as I look around, we seem to be losing ourselves. If we want to achieve excellence in technology, why can't we achieve excellence in being good to each other?"

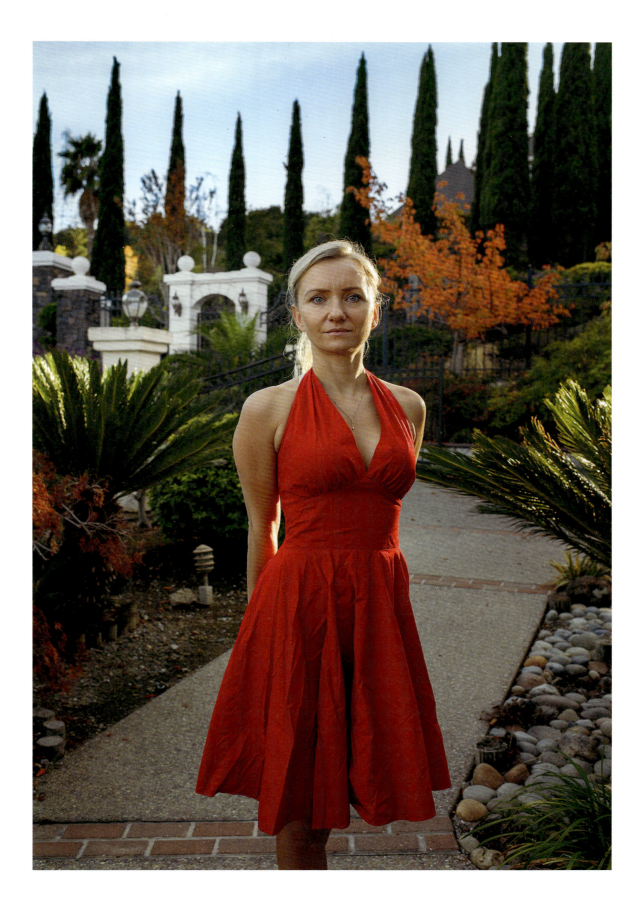

TERESA

Teresa works full-time in a food truck. She prepares Mexican food geared toward a Silicon Valley clientele: hand-milled corn tortillas, vegan tamales, organic Swiss chard burritos. The truck travels up and down the valley, serving employees at Tesla headquarters, students at Stanford, shoppers at the Whole Foods in Cupertino.

Teresa comes from Mexico. She lives in an apartment in Redwood City with her four daughters. On the door is a drawing in crayon that announces, "Bienvenidos Abuelos: Welcome, Grandparents." In the last few weeks, Teresa's parents have been visiting from Mexico. She hadn't seen them since she was a teenager, twenty-two years ago. "Es muy difícil para uno," she says. "It's really hard."

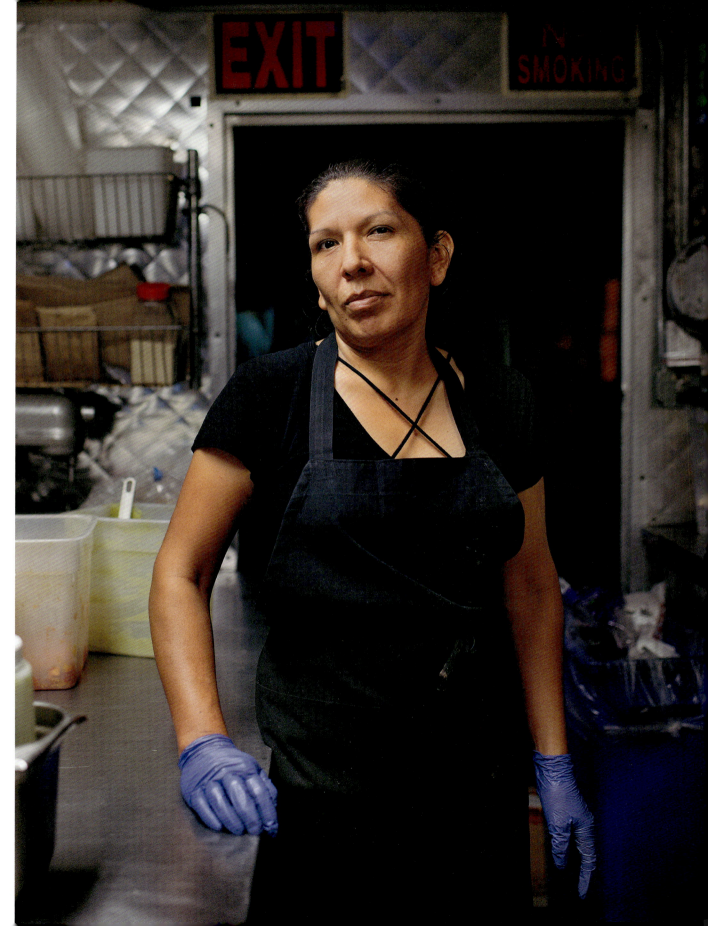

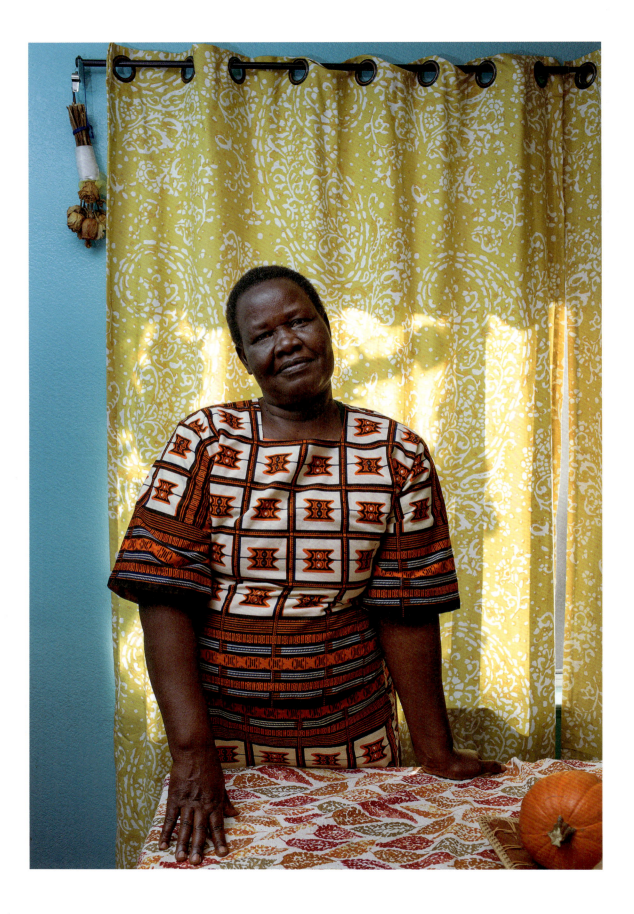

"THERE ARE PEOPLE
HERE WHO ARE POORER
THAN WE ARE IN AFRICA,
BECAUSE YOU CANNOT
FIND A HOMELESS PERSON
IN MY VILLAGE."

MARY

"I've discovered one thing," Mary says. "There are
people here who are poorer than we are in Africa,
because you cannot find a homeless person in my
village. They have their small huts, they have their
land, they can grow their crops....They can get
water if the government drills for them. They go for
firewood from the forest—they live with nature. They
don't become homeless. And because our commu-
nity cares for each other, because we live according
to clans, when you have a problem, someone is
going to come and at least try and solve your
problem, if it can be solved. If I am sick I don't have
to worry, because I can just tell people I'm sick and
somebody will come and take care of me. . . . We
care for our own until they die in our hands. And as
you're dying there are so many people—all of your
relatives are sitting around, either praying or singing."

Mary came to the United States a little more
than a year ago from Uganda. She taught English all
over Africa to make money to put her three daughters
through school. Now she lives with her middle
daughter's family in San Jose.

In Africa, says Mary, "you're never alone. This
place is lonely. I even wanted to go back last year.
It is lonely. Lonely."

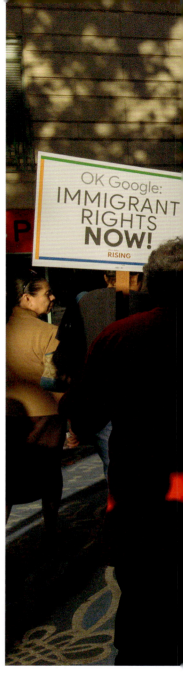

Ribbon-cutting ceremony, company office opening, Mountain View

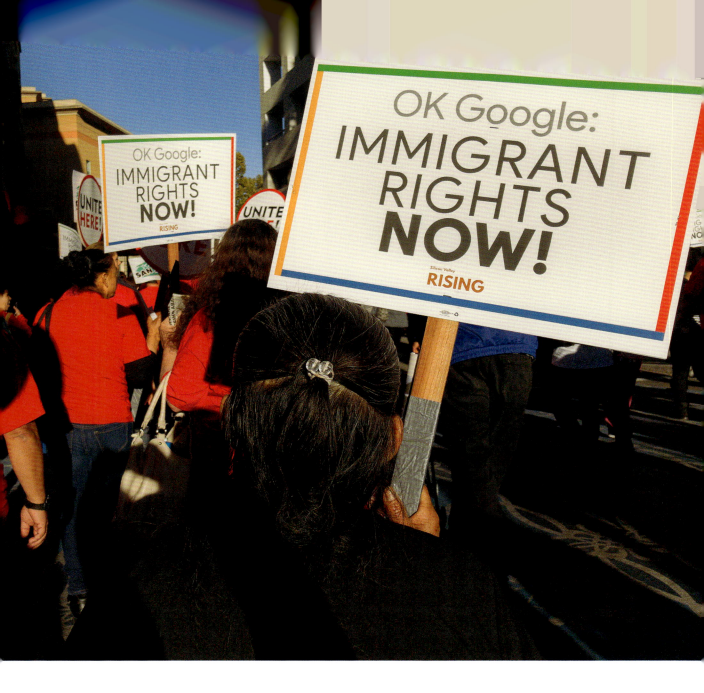

Workers' rights rally, San Jose

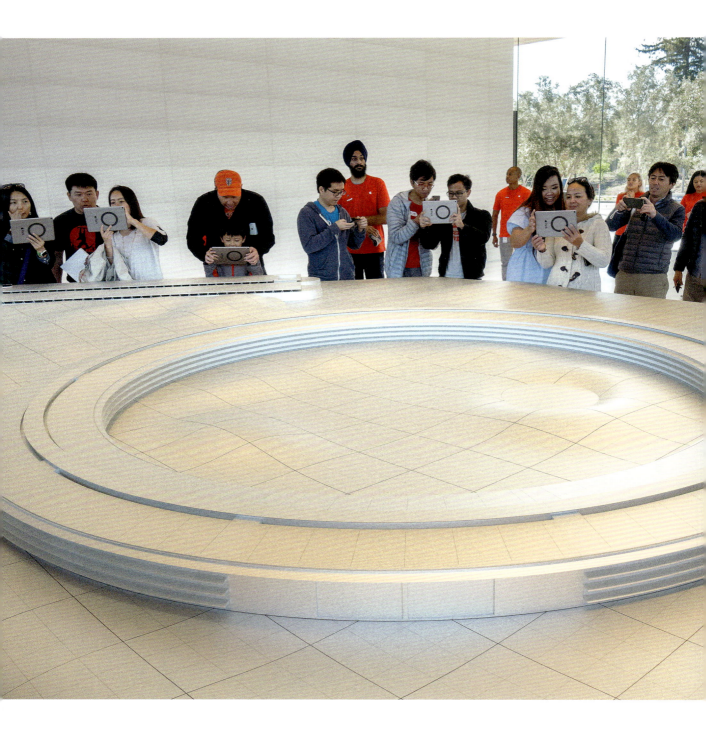

Augmented reality display of Apple's headquarters, Apple Park Visitor Center, Cupertino

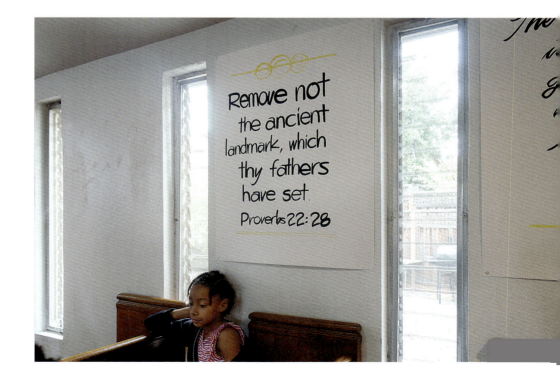

Menlo Park Community Church of God in Christ, Belle Haven

"I'VE SEEN THEM WHEN THEY'VE GONE UP, AND I'VE SEEN THEM FALL. THEN THEY BECOME HUMBLE AGAIN."

DIANE

Diane lives in a spacious house in Menlo Park appointed with beautiful objects from a life of travel with her late husband, a Chinese businessman and philanthropist. The couple moved to the Bay Area when he retired, over thirty years ago, and they loved it here—the sunshine, the ocean, the wide-open spaces. Since then, she has watched the area change: "It's overcrowded now. It used to be lovely, you know—you had space, you had no traffic. Here it was absolutely a gorgeous place. Now it's heavily populated—buildings are going up everywhere like there's no tomorrow.

"The money that rolls here is unbelievable," Diane continues, "and it's in the hands of very young people now. They have too much money—there's no spiritual feelings, just materialism. I see it, I really see it. They've lost human feeling. . . . The young people—it comes to them so suddenly, so fast. I've seen them when they've gone up, and I've seen them fall. Then they become humble again."

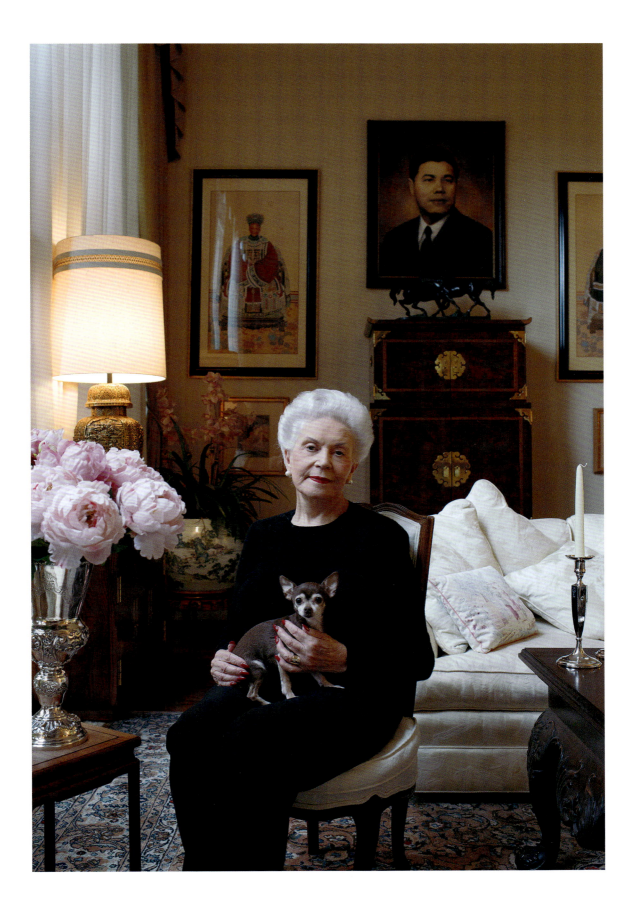

Voice-controlled personal assistant, Los Gatos *New Teslas headed north, Highway 101*

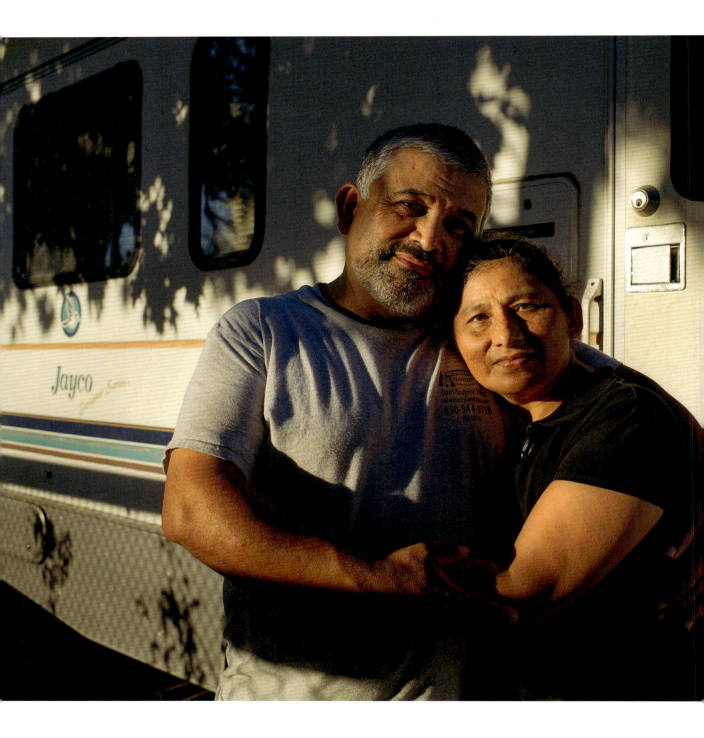

ABRAHAM and BRENDA

Abraham and Brenda have been married for twenty-eight years. Abraham made a solid living as a tile setter, but they lost their house after the crash of 2008. They lived for a time in improvised shacks that friends had set up in their backyards, which are common but illegal and unsafe. Twice the police ordered the dwellings demolished, and each time Abraham and Brenda had to move. So they finally took their savings and bought a trailer, and now they live in a long row of trailers in Palo Alto, parked in front of the Stanford campus. This usually works out okay, but there are times—like on the day of a big football game—when the university demands that the trailers clear out. On those days, Abraham and Brenda drive over the hills to Half Moon Bay and look out at the sea.

Oracle field office, San Jose

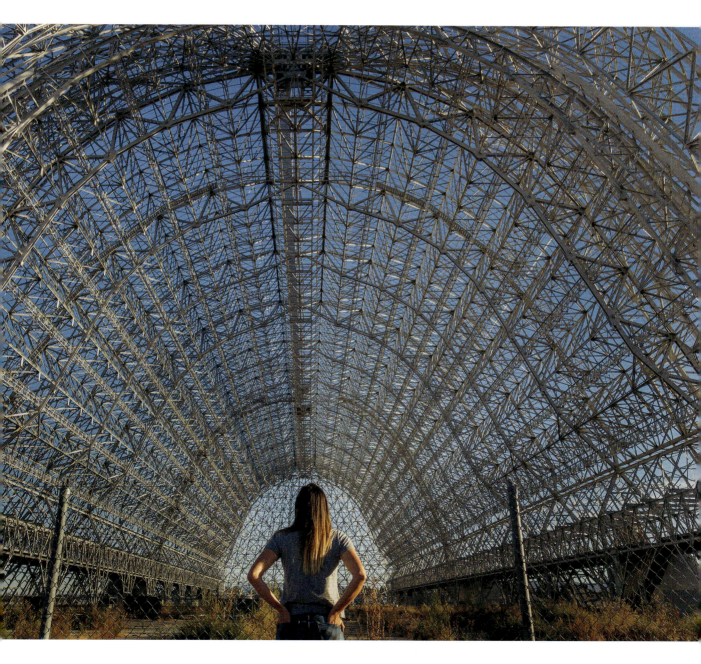

Leslie at Hangar One, Moffett Federal Airfield, Mountain View

ARIANA and ELIJAH

Ariana remembers that it was sometime last spring when she'd returned home from school to find men placing "weird little metal contraptions" all over her apartment. They were using the instruments to test the air, her mother said, inside and out of the Sunnyvale apartment complex where Ariana lives with her family. The men found that the air was contaminated with trichloroethylene (TCE) fumes.

TCE is a cancer-causing solvent. From the 1950s to the 1980s, when the electronics designed in Silicon Valley were still made there, local manufacturers used it to clean silicon wafers before etching them with circuitry. Tons of TCE leaked into the ground. Now TCE had been found in the soil and the groundwater behind Ariana's home, where a developer was planning to build a luxury apartment complex.

The men soon returned to install two filters in Ariana's apartment: one in the living room and one in the bedroom that she shares with her younger brother. "At first I was kind of freaked out," she says, to think that her family had been inhaling cancer-causing chemicals. And the filters themselves were kind of a nuisance: "They want us to run them on high all the time, but they're really loud, so we don't always have them on high. . . . I don't know if the air filters are necessarily doing anything. I think part of it is them trying to give us peace of mind."

Ariana says the men come back every few months to repeat the tests, but apart from that she doesn't think much about the air anymore. She and her boyfriend, Elijah, are looking forward to finishing high school and moving away from the valley. They think Texas would be a nice place to live.

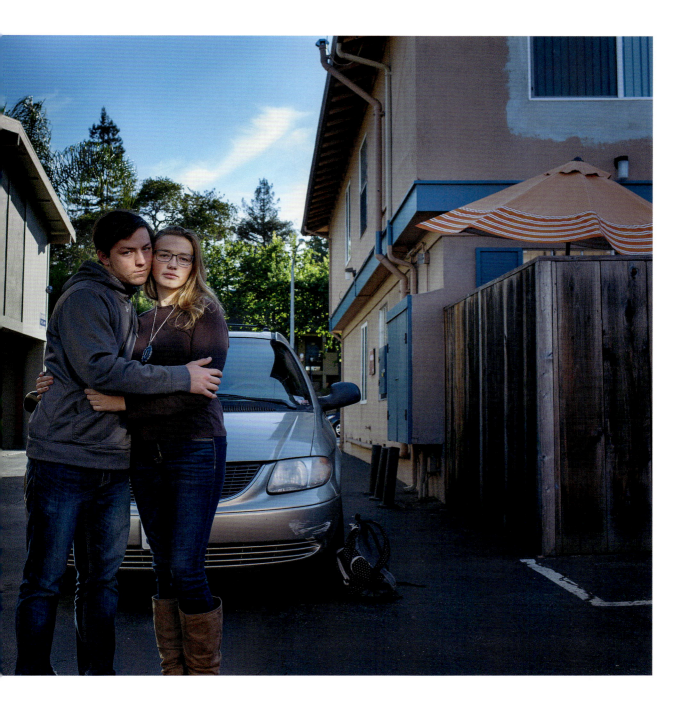

"AT FIRST I WAS KIND OF
FREAKED OUT," ARIANA SAYS,
TO THINK THAT HER FAMILY
HAD BEEN INHALING CANCER-
CAUSING CHEMICALS.

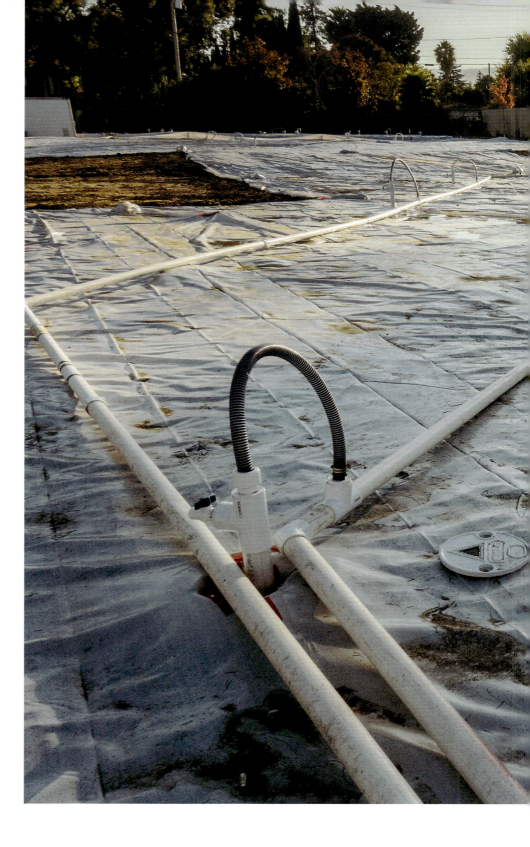

Superfund site remediation, Mountain View

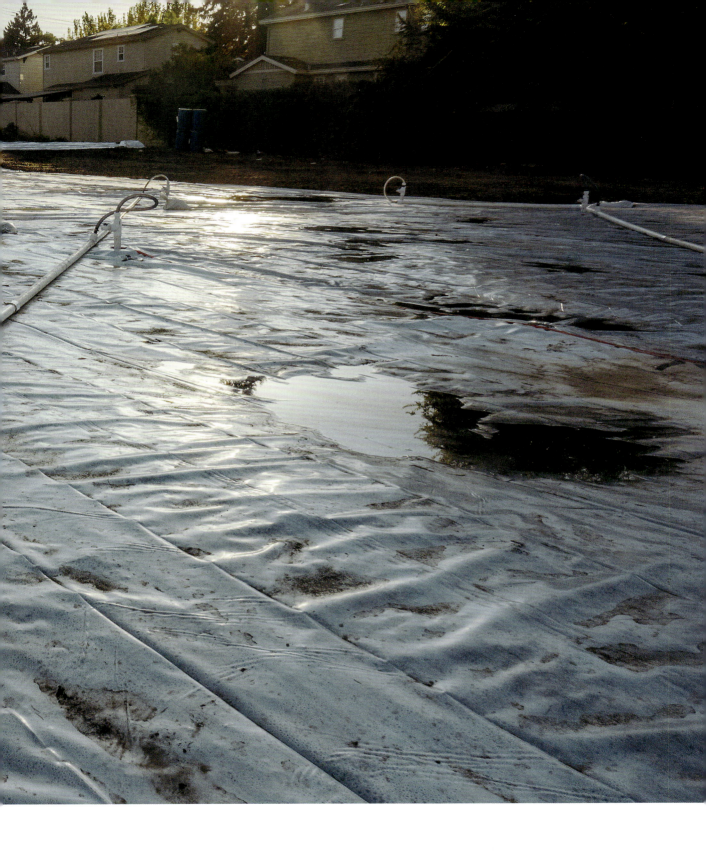

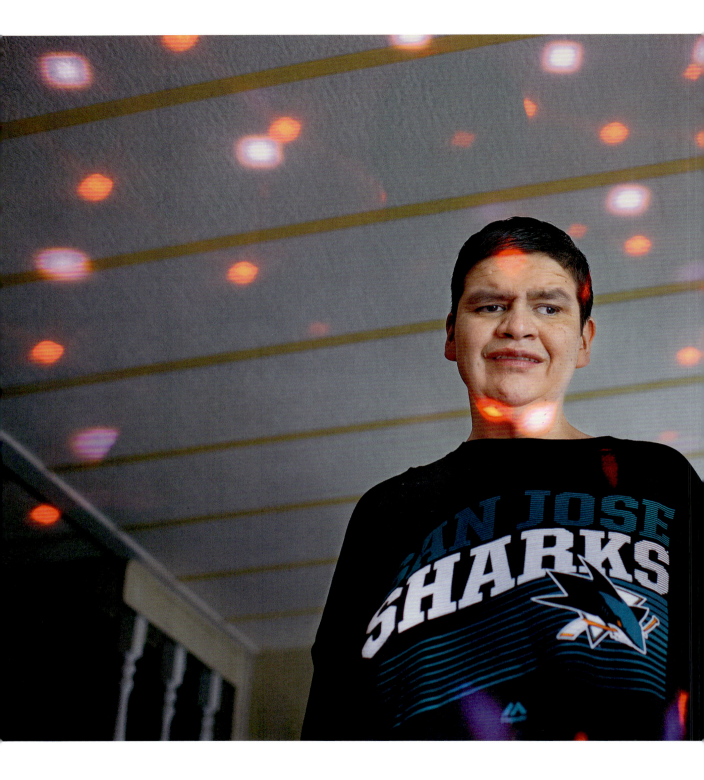

MARK

It was the 1970s, and Mark's mother was working in an electronics plant in Mountain View. Yvette made the lasers that scan groceries in a supermarket and earned $2.70 an hour. She had to heat a green powder with a blowtorch and fuse two pieces of glass together. Every evening, when Yvette got home from work, green gunk would be all over her face and in her nose. Newly married, Yvette became pregnant. One day at work she began to have cramps and went to the bathroom. She had a miscarriage.

A few years later, Yvette's son, Mark, was born. The baby's eyes were crossed, his hips were dislocated, and he had severe brain damage. Doctors told Yvette that he would never talk, never interact with others. Mark didn't crawl when he was supposed to, didn't walk. He required constant care. Years later, Yvette heard an ad on the radio from a law firm asking women if they had worked in the electronics industry and if they had a child with symptoms that sounded like Mark's. She called the law firm.

Yvette learned that the green mixture that she had been handling and inhaling was over 60 percent lead, a substance known since the time of the ancient Romans to cause miscarriages and birth defects. Today, the electronics that are designed in Silicon Valley are manufactured in other countries, often in Asia, and many with few regulations to protect workers from toxic chemicals.

Mark is thirty-nine now. He still requires constant care and can say only one or two words at a time. Not being able to express himself frustrates him, and he once broke his hand by slamming it against a wall. He loves to play with his stuffed animals and to eat at Chuck E. Cheese. He loves to sing along with his karaoke machine, with its pink and red lights swirling all around him.

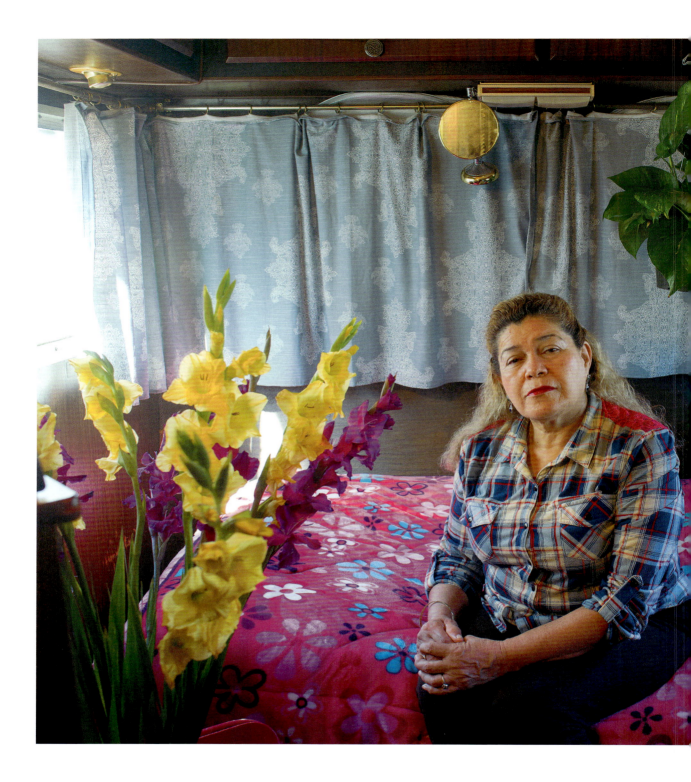

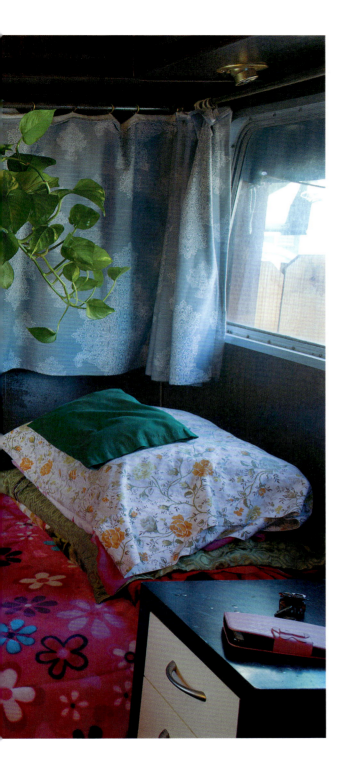

IMELDA

Imelda works for a cleaning service. In the early morning, six days a week, she gets picked up by a coworker who drives her to Atherton, one of the wealthiest towns in America. To reach the houses she cleans, she often passes through huge metal gates, up driveways flanked by fruit trees and security cameras. There have been days, she says, when she's worked in eight of them. A recent pay stub logs her hours, including overtime, amounting to $1,122 for two weeks' work.

With housing prices what they are, Imelda lives in a trailer in a friend's driveway. She has no utilities in the trailer, so she goes in and out of her friend's cottage to use the bathroom and kitchen—which are crowded, because there are three generations living there. In Imelda's sink sits a strainer of persimmons and guavas, gifts from the people whose houses she's cleaned.

Stairs to observation deck overlooking Apple Park, Cupertino

Imelda's doorway, Redwood City

THE WORST PART IS
THAT HE HEARS THE
EMPLOYEES ARE NOW
TOO SCARED TO TALK
ABOUT THE UNION.
HE BELIEVES THAT
ALL HIS HARD WORK
HAS BEEN IN VAIN.

RICHARD

Richard has spent his entire adult life in the auto industry, loving his work and making good money. In 2010, the year that GM went bankrupt and the plant he worked at in Fremont closed, he was earning $120,000 a year. After Tesla took over the plant, Richard got a job on the manufacturing floor. He was paid $18 an hour, or less than $40,000 a year.

Richard started noticing things that didn't seem right. As a line worker assembling car doors, he was required to work twelve-hour shifts, five or six days a week. Richard had a home, but he noticed young guys "who came in broke, with a bag of clothes" being hired, working the long shifts, sleeping in their cars, showering in the break room, and doing it again the next day. When a friend invited Richard to meet with the United Automobile Workers union, he agreed. Soon after that, when people complained to him about the low pay or long hours, he'd tell them that with the union, they could stand up for themselves. He handed out buttons and T-shirts, told people they had a choice. "We don't want to break 'em," he said of the company. "We just want a little larger piece of the pie—so we can have a cooler of beer every now and then, go camping once in a while."

Though he'd never received a negative review, Richard was fired last October, along with more than four hundred other workers. The UAW has filed a complaint, alleging that Tesla fired workers who were trying to unionize. The worst part for Richard, he says, is that he hears the employees are now too scared to talk about the union. He believes that all his hard work has been in vain.

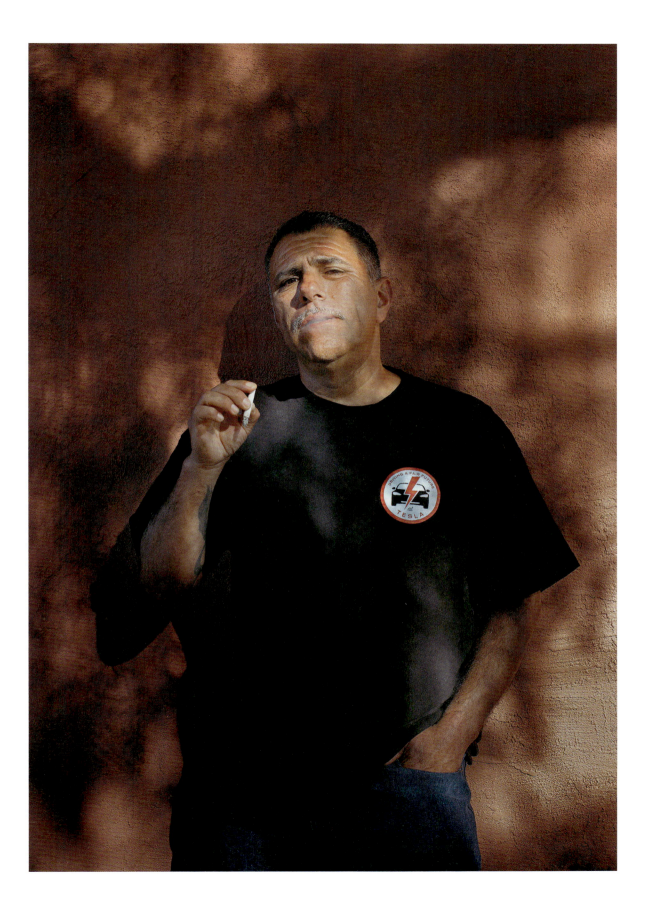

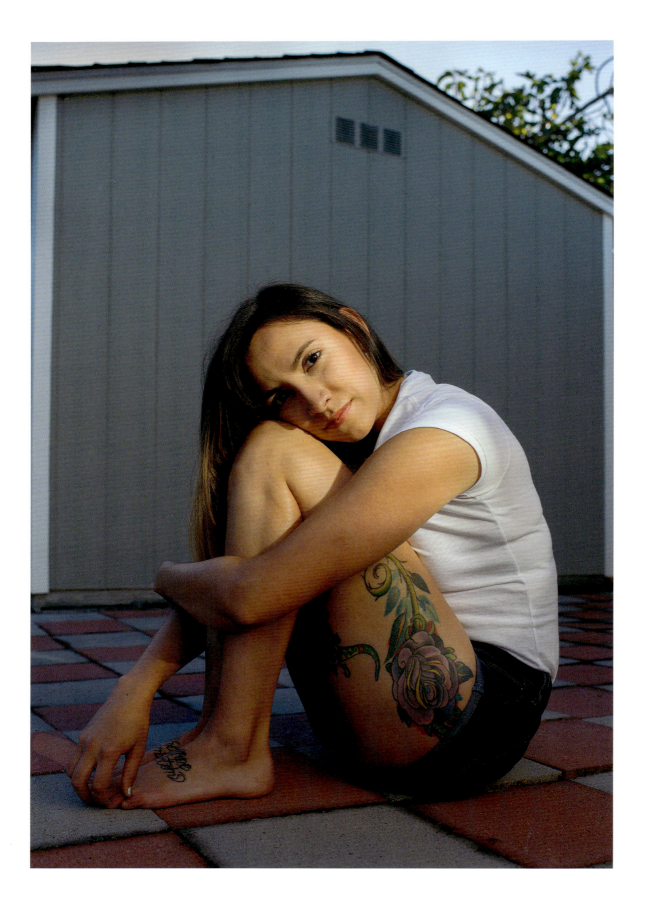

LESLIE

Leslie grew up in Gallup, New Mexico. Her grand-
mother is Navajo, and Leslie has spent more
than half her life on the reservation, running with
her cousins and fetching water from behind the
mud-covered hogan where her grandmother raised
twelve kids. Leslie loved four-wheeling and elk
hunting; she was also a star student and became
interested in science when an astronaut visited her
school. Now she works as an engineer at NASA.

Leslie designs instruments to search for life in
space—on Enceladus and Europa, the moons of
Jupiter and Saturn. She is almost always around
men, and she sometimes thinks she's more aggres-
sive, less fearful, than the other women she meets
in Silicon Valley.

"The women that I knew in New Mexico," she
says, "were kind of rough around the edges. We can
be fierce, confrontational, because that's the culture
out there. That's what you need to do to survive."

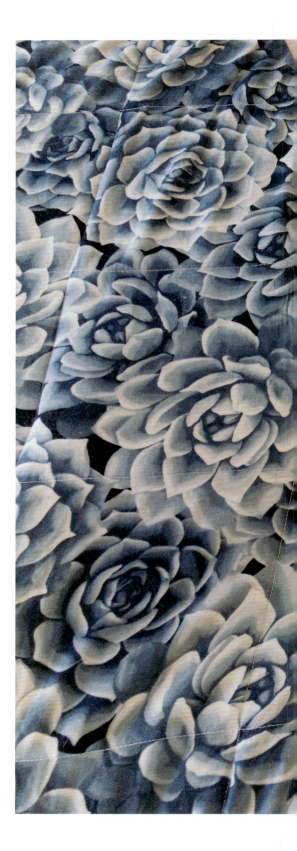

"Carpe Diem," "Carpe Noctem," Leslie's tatoos, Sunnyvale

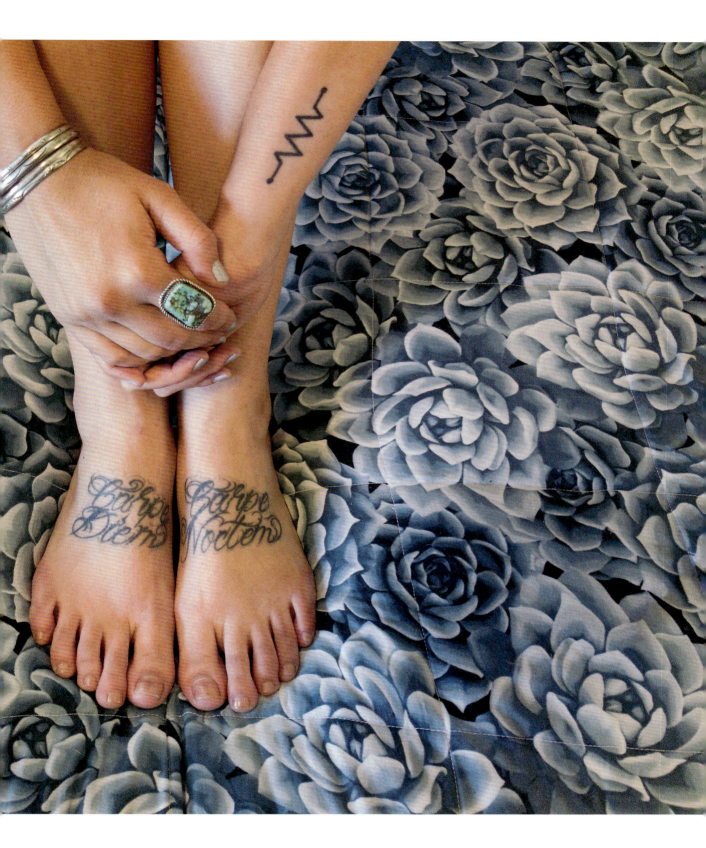

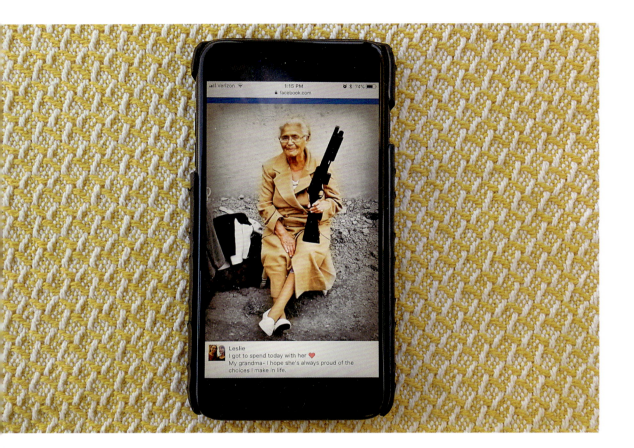

Leslie's grandmother, Navajo Nation, New Mexico

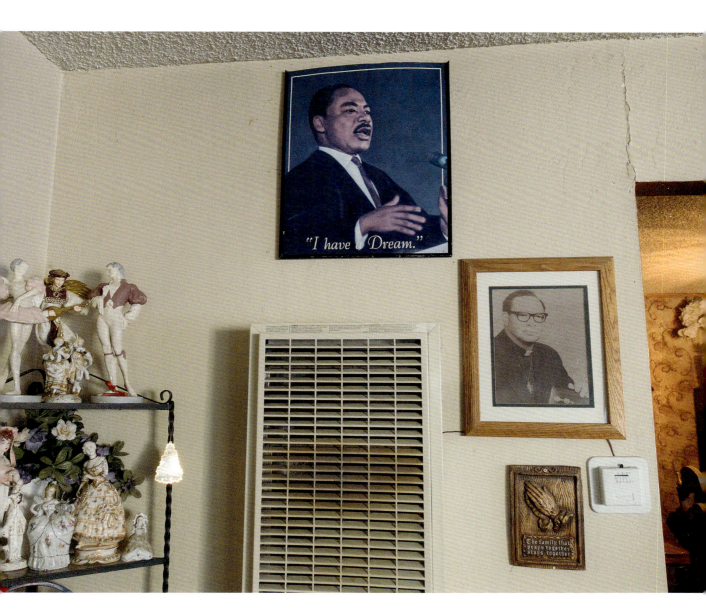

Geraldine's living room, Belle Haven, Menlo Park

GERALDINE

One day Geraldine received a phone call from a friend: "They're taking our churches!" her friend said. It was a couple of years back, when Facebook was expanding and buying up property in Geraldine's Menlo Park neighborhood. Her father-in-law had established the tiny church fifty-five years before, and Geraldine couldn't let it be torn down. The city council was holding a meeting for the community that night. "So I went to the meeting," she says. "You had to write your name on a paper to be heard, so I did that. They called my name and I went up there bravely, and I talked."

 Geraldine doesn't remember exactly what she said, but she stood up and prayed—and, ultimately, the congregation was able to keep the church. "God really did it," she says. "I didn't have nothing to do with that. It was God."

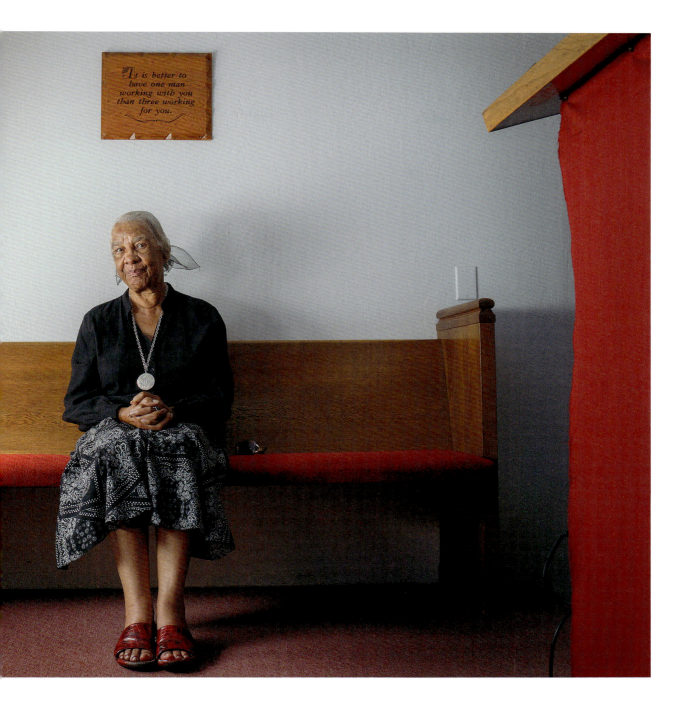

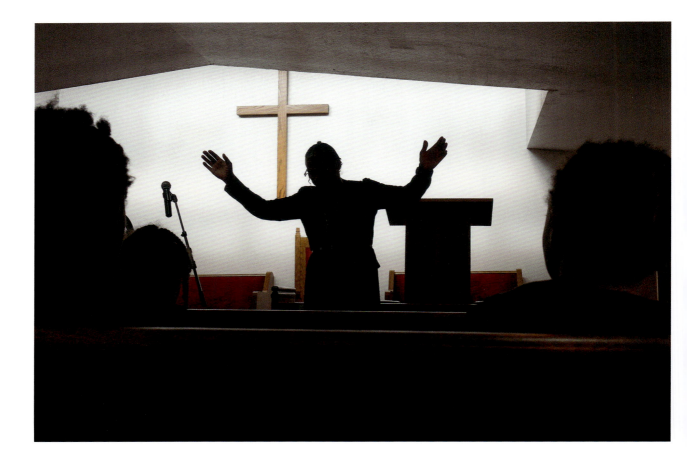

Menlo Park Community Church of God in Christ, Belle Haven

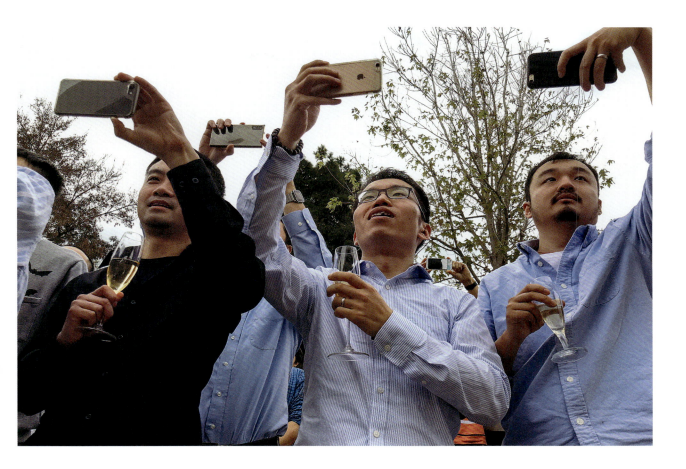

Ribbon-cutting ceremony, company office opening, Mountain View

JOLEA

Jolea spent her early childhood in rural Northern California, free to explore the open country. But her mother was unhappy with the local schools, and she did some research online. She saw that Los Altos High School was rated at the top. So, like many parents who have come to Silicon Valley to benefit their children, the family traded their three-bedroom house for a one-bedroom apartment in the heart of the valley.

While her parents share the bedroom, Jolea has made the living room into her space. Her bed is tucked under a window by a tiny balcony overlooking the apartment complex; her clothes hang on a nearby rack with wheels.

Since moving here, Jolea has attended computer-coding camp at Stanford and entered the ninth grade. She's heard her schoolmates talk about the stress of being a teenager in Silicon Valley—the high expectations of successful parents, the competition to get into the very best colleges. But the fourteen-year-old says she feels confident in her own goals, and that her family won't push her to overachieve. She's working hard for herself, she says, not them.

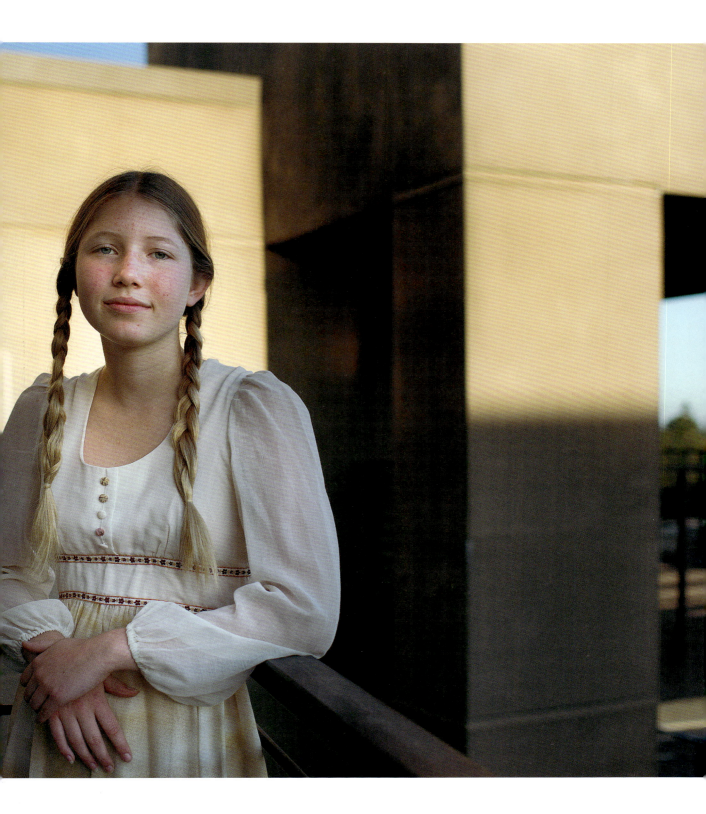

MELISSA and STEVE

After their nineteen-year-old daughter Stevie died by suicide in 2006, Melissa and Steve sought comfort by trying to help others. As volunteers with Kara, a grief support agency in Palo Alto, they've spent the past decade counseling parents of children as young as twelve who have taken their lives. When clusters of teen suicides emerged at two local high schools in 2009 and 2014, they were on hand to help.

"There is the implication of moral bankruptcy in Silicon Valley," says Steve, "but I don't think that's the case. Parents have the best intentions. But they tend to think it's a competitive world, so 'I've got to teach my child to excel. If they excel, they'll be able to compete. They'll be equipped to cope and be happy.'"

Steve says that "the common denominator of people that commit suicide in this increasing phenomenon, particularly in the Bay Area, is that they are more sensitive than average." He and Melissa describe children who take everything to heart, who don't know yet what they think and feel, who need time and space to process their lives. Instead, these children find themselves falling off the treadmill that the culture has set them on.

"Our intelligence has surpassed our ability to express our emotions," says Melissa. "We don't learn about our feelings and how to express them. As a matter of fact, what we learn from a very young age is how not to express our feelings—how to keep 'em inside, how to hide 'em, how to get on with it. How to achieve.

"It's hard to believe," she says, "that we're human underneath all this stuff that we see on the outside. We think, 'We're Silicon Valley: we're the products of Silicon Valley, or the makers of Silicon Valley.' And we're really humans trying to survive under all of the facade that everyone sees."

dear Everyone

im sick of being a bad daughter. im sick of not looking forward to
not liking myself.

i will never be excellent at anything. i am bad at life.

i have way more than i deserve to have and i am not good e

i am not super smart or talented. i feel like im a burden
dealing with me gone.

im sorry. death may be a selfish choice but forcing m

rry to mom because she will never under

to dad because no one want

Stevie's suicide note, Los Altos

Facebook employee shuttle bus, Menlo Park

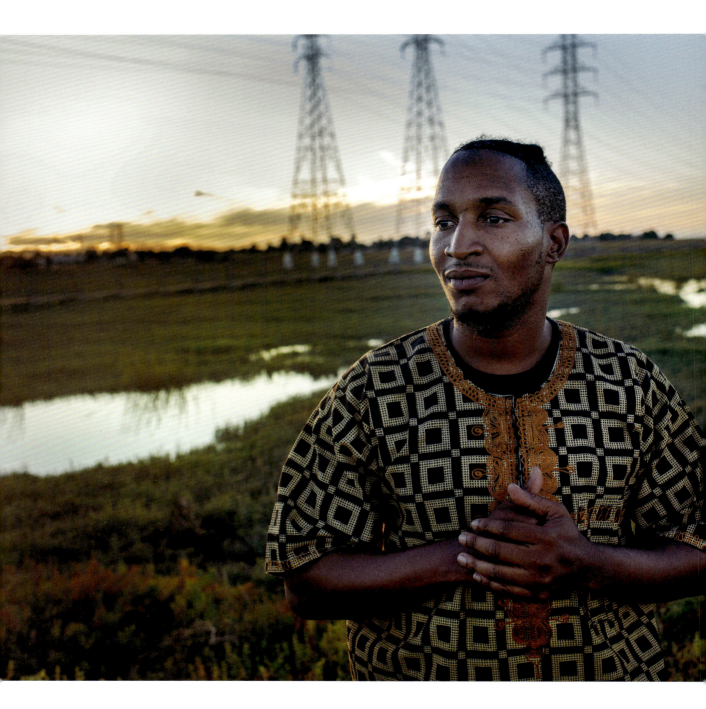

AS JON ADVANCED IN HIS
CAREER, HE REALIZED
THAT WHEREVER HE WENT
THERE WERE VERY FEW
PEOPLE WHO LOOKED
LIKE HIM.

JON

Jon lives in East Palo Alto, along the marshy edge of San Francisco Bay, separated from the rest of Silicon Valley by Highway 101. When he was growing up, in the 1990s, the city was home to a large Black community, which has since been replaced by Spanish-speaking residents.

By the time Jon was in the eighth grade he knew he wanted to go to college, and he was accepted by a rigorous private high school for low-income children. He discovered an aptitude for computers and excelled along this path, through university coursework and professional internships. Yet, as he advanced in his career, he realized that wherever he went there were very few people who looked like him.

"I got really troubled," he says. "I didn't know who to talk to, and I saw that it wasn't a problem for them. I was just like 'I need to do something about this.'"

Jon, now in his thirties, has come back to East Palo Alto and works with an organization called StreetCode Academy, which offers free computer-coding classes that would cost hundreds of dollars in the more affluent towns nearby. He's worked to maintain Makerspaces—places for students to collaborate on tech-related projects—in all the city's schools, to fundraise for paid volunteers to work with the kids, and to attract high-quality technology and engineering teachers.

"There are a lot of communities like East Palo Alto that are next to the tech giants," he says. He cites Amazon, which in 2017 leased office space in this city for 1,300 tech employees, but which has failed to hire as many local residents as it promised to do when it set up shop.

Today, says Jon, "I don't know anyone who works there. Anyone that I knew that worked at Amazon was on the bottom floor, either working security or sweeping the garbage."

TOGETHER, THE COUPLE EARNS MORE THAN SIX TIMES THE NATIONAL HOUSEHOLD AVERAGE.

GEE and VIRGINIA

In 2009 Gee cofounded a tech startup that's developing an online auctioning app. His office used to be in Mountain View, but to cut costs the company moved to Santa Clara and laid off five workers. Virginia works in the finance department of Hewlett-Packard, in Palo Alto.

In 2016, the couple bought a five-bedroom house in Los Gatos: big enough for each of their two children to have a bedroom and for their parents to visit them from Taiwan. Together, the couple earns about $350,000 a year—more than six times the national household average. Houses on their street cost just under $2 million when they bought theirs. They would like to have nice furniture, but between their mortgage and child-care expenses, they don't think they can afford to buy it all at once. Some of their rooms now sit empty. Gee says that Silicon Valley salaries like theirs sound like real wealth to the rest of the country, but here they're what it takes just to be in the middle class.

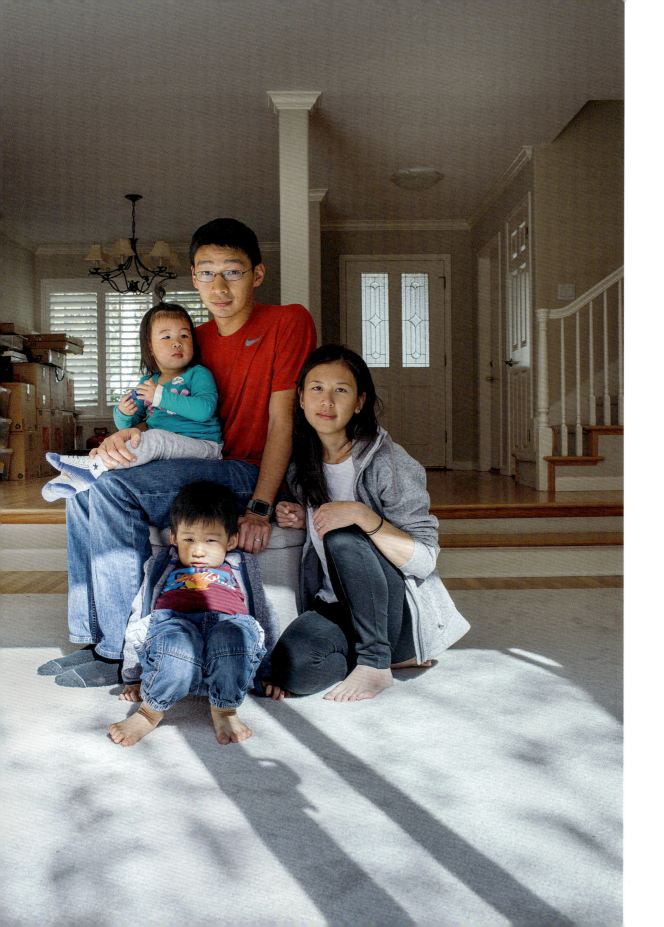

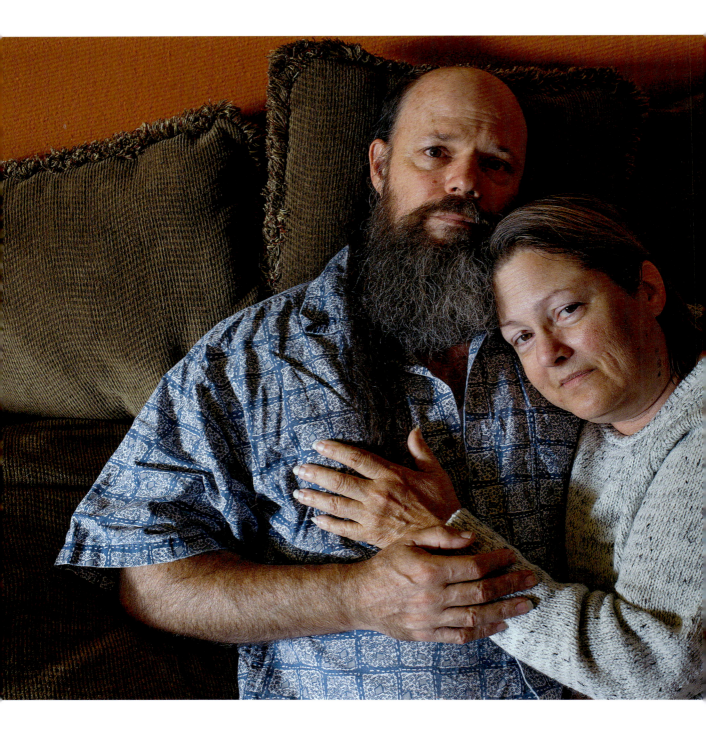

BRANTON and SHIRLEY

Branton's father begged him to go to college, but
Branton was making too much money to listen.
At seventeen, he earned three times the minimum
wage as a union dishwasher; at twenty-three, he
became an ironworker, making $14.47 an hour. His
father had said that manual labor would ruin his
body. Now in his fifties, Branton has eight screws
fusing his vertebrae and is often in pain.

Branton's wife, Shirley, was proud of him when
he got a job at Tesla four years ago working on
electric cars. Branton knew about the company's
multibillionaire owner, Elon Musk, and was excited
about his vision—clean technology, sustainable
energy. But while Musk promoted his new ideas,
Branton saw workers getting injured—"bending
and twisting, blowing out shoulders, blowing out
their backs." He volunteered as a safety coordinator
to protect the younger guys but resigned when
the company ignored his suggestions. Now, Musk's
vision sounds to him like an empty game. "With
Elon screwing up, we're all gonna lose," he says.
"We're all gonna lose."

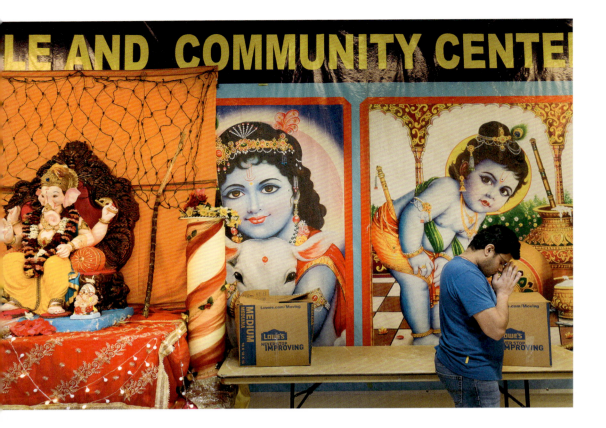

Sunnyvale Hindu Temple & Community Center, Sunnyvale

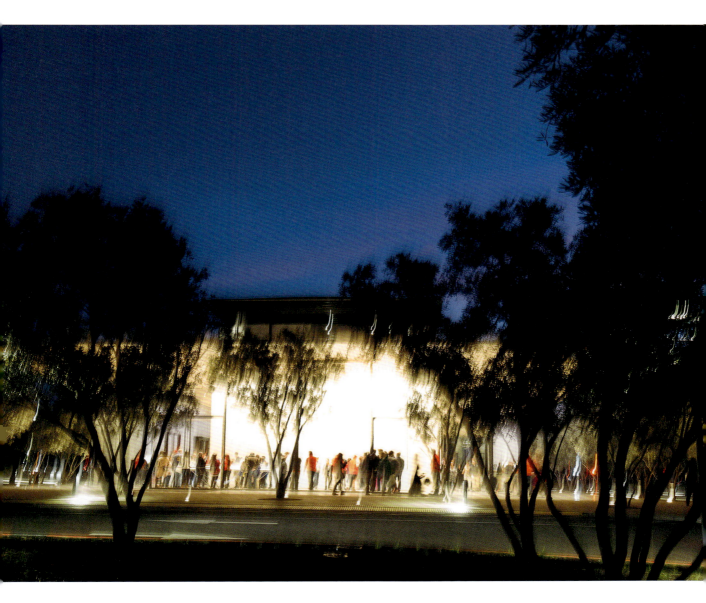

Grand opening, Apple Park Visitor Center, Cupertino

WHEN KONSTANCE AND HER TWO DAUGHTERS MOVED TO WITHIN WALKING DISTANCE OF THE FAMILY'S SCHOOL, SHE WAS SUDDENLY SURROUNDED BY SOMETHING SHE'D BEEN MISSING: TIME.

KONSTANCE

As a teacher, Konstance is one of the thousands of public servants in Silicon Valley who can't afford to live in the places they serve. For years she joined the commuting firefighters, police, and nurses sitting for hours in traffic on the freeways around San Francisco Bay.

The situation "really pushes away the people who would make the most impact," says Konstance. "We could be more effective if we lived a little closer, plus it would feel more like a community."

In July 2017, Konstance won a place in a lottery run by Facebook. It offered apartments to twenty-two teachers in the school district adjacent to the company's Menlo Park headquarters. The teachers would pay 30 percent of their salaries for rent; Facebook would make up the difference. So Konstance and her two daughters moved to within walking distance of the family's school. Suddenly, she was surrounded by something she'd been missing: time. Time to make hot meals at home rather than eat in the car, time for her daughter to join the Girl Scouts. Time for Konstance to pursue her own studies and still get to bed at a reasonable hour.

But she didn't feel secure. The program was a pilot, intended to last for only five years. By 2019 she was anxious about whether she'd have to move again, and how she'd come up with first and last month's rent. Then, in the fall of 2019, Facebook announced a one-billion-dollar commitment to creating affordable housing in the area. Twenty-five million of Facebook's gift would go toward building housing: 120 apartments, including for Konstance and the other teachers in the original pilot, for as long as they were working in area schools.

Konstance expects to receive one of the new apartments, but she can't be sure. What she's learned about the program comes from the newspaper and the local grapevine. She still hasn't heard directly from Facebook.

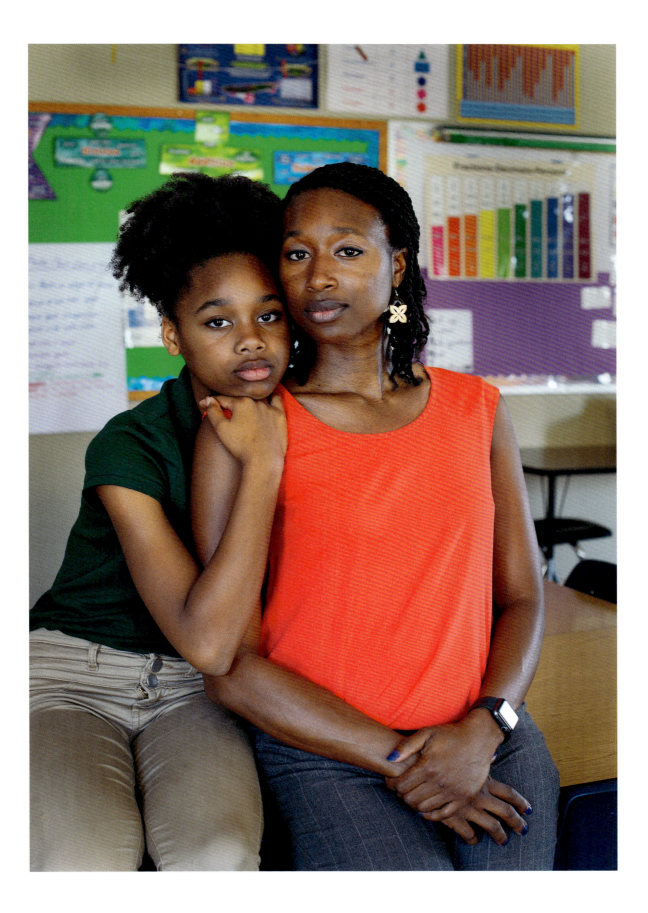

AURORA

Aurora visits the Pao Hua Buddhist Temple in San Jose every Wednesday. She lights incense and bows three times before each statue of the Buddha. She believes in the special powers thought to be possessed by the Buddhas here—one who will help you find a mate, another who will help you have a baby. Aurora prays for her ancestors and for the health of her parents, herself, and their business.

Aurora emigrated from China to California eight years ago. In 2014 she and her parents started a restaurant called Thousand Tasty in a residential neighborhood in Milpitas, a small city on the northeastern edge of San Jose.

Her lunchtime customers' suits and heels and their plastic ID badges tell Aurora that they work at companies like Cisco, Tesla, and Intel. They eat quickly and return to work. In the evenings, local families take their places.

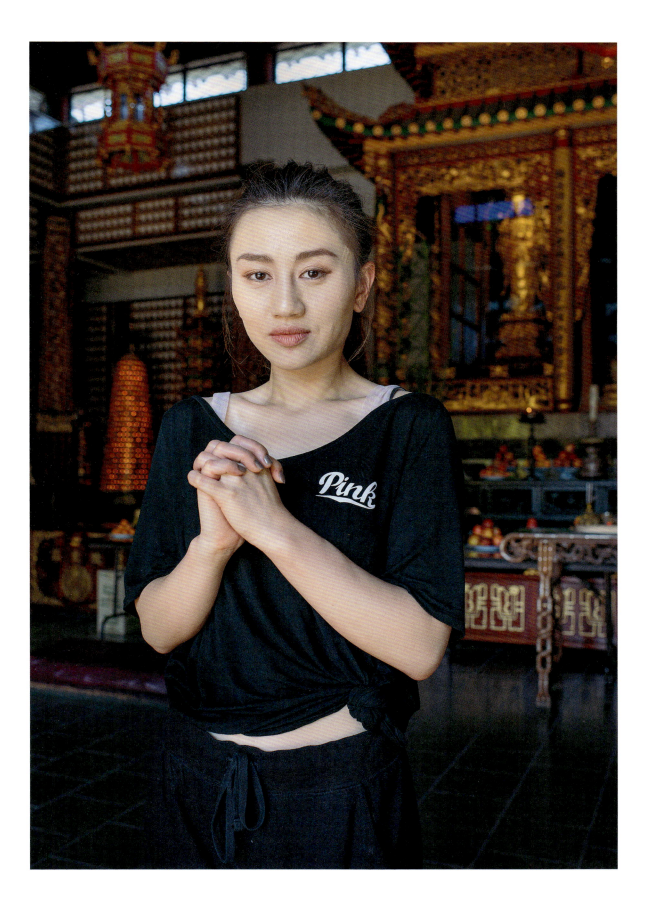

Memorial, Pao Hua Buddhist Temple, San Jose

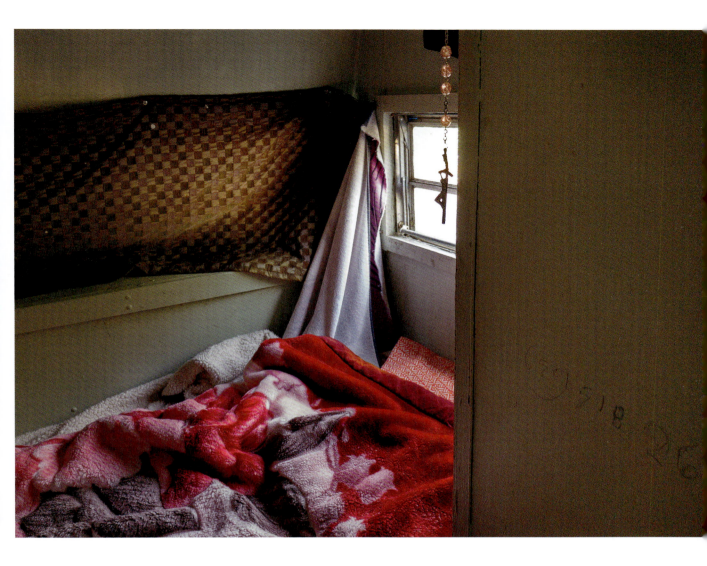

Victor's bedroom, Mountain View

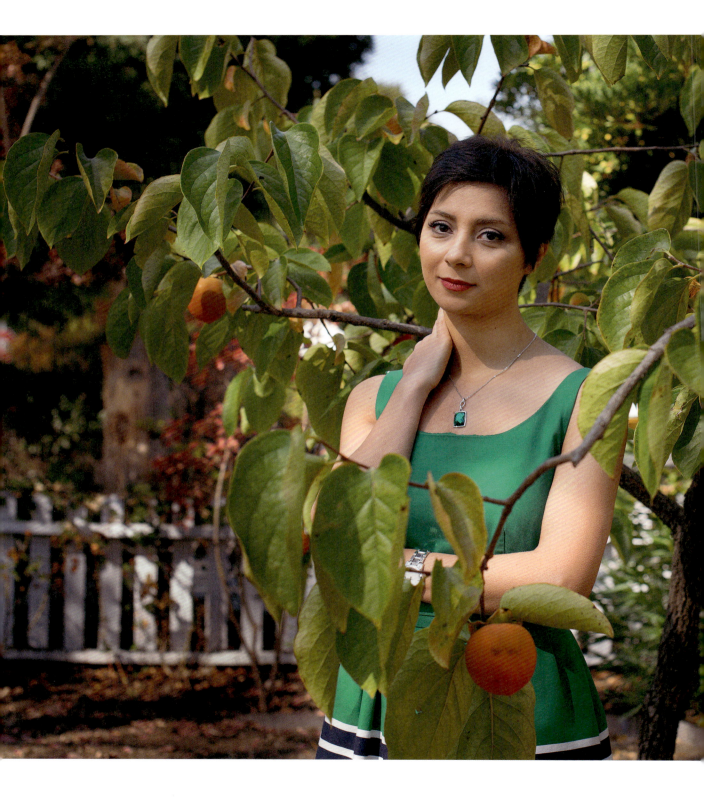

> "IT'S NOT THAT EASY—
> COME HERE, LIVE IN
> CALIFORNIA, BECOME
> A MILLIONAIRE. IT'S
> NOT THAT SIMPLE."

ERFAN

"It is amazing living here," says Erfan, who came to Mountain View when her husband got a job as an engineer at Google, "but it's not a place I want to spend my whole life. There are lots of opportunities for work, but it's all about the technology, the speed for new technology, new ideas, new everything.

"We never had these opportunities back home, in Iran. I know that—I don't want to complain. When I tell people I'm living in the Bay Area, they say, 'You're so lucky—it must be like heaven! You must be so rich.'

"We really pay too much for it all," Erfan continues. "Not in physical costs, but in emotional costs. We are sometimes happy, but also very anxious, very stressed. You have to be worried if you lose your job, because the cost of living is very high, and it's very competitive. It's not that easy—come here, live in California, become a millionaire. It's not that simple. The cost is too much."

Erfan's grandmother's pearls, Mountain View

Family portrait from Tehran, Mountain View

Apple Park Visitor Center, Cupertino

Imelda's altar, Redwood City

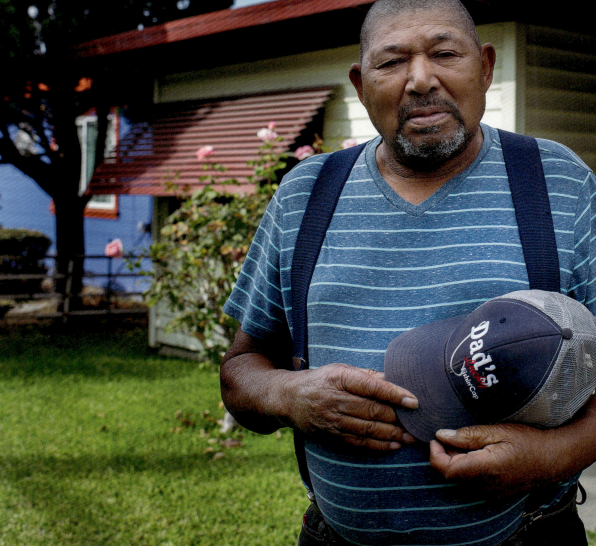

"IF I SELL MY HOUSE,
WHERE AM I GONNA GO?
BACK TO THE WHITE
MAN?"

TED

Ted moved to Silicon Valley from Pelican, Louisiana, in 1962. He got a job working construction and bought his house for $9,500. He lives in Belle Haven, a historically Black neighborhood in Menlo Park, not far from Facebook's headquarters. Belle Haven has for years felt separate from the rest of Silicon Valley—physically, culturally, and politically.

These days, realtors are always sending Ted letters, calling him on the phone, knocking on his door. They say he could get nearly a million dollars for his house. But he always refuses. "If I sell my house," he says, "where am I gonna go? Back to the white man?"

Ted says he sees his old neighbors moving out, being replaced by Asians. He says he thinks they're from China. He hears they pay cash.

Facebook expansion, Menlo Park

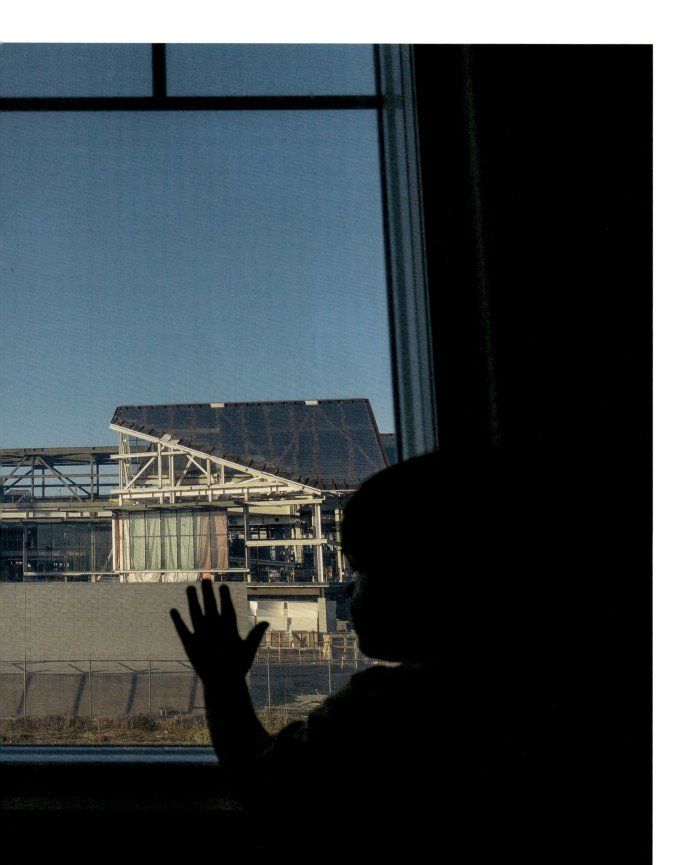

"WHAT ABOUT THE YOUNG PEOPLE, THOSE WHO NEED JOBS, FROM *WITHIN* THIS COMMUNITY?"

ELISA and FAMILY

In 2008 Elisa and her family bought a plot of land in Menlo Park and built a "smart" house—self-cooling, self-heating, with solar panels. The whole thing cost $450,000. Ten years later, with the start of Facebook's fifty-six-acre expansion, the house has doubled in value. "It's fantastic," Elisa says.

At a recent community meeting, Elisa got a chance to ask a question of Mark Zuckerberg, Facebook's CEO. Referring to the local children of color, who don't match the well-educated, international profile of Facebook's employees, Elisa said, "What about the young people, those who need jobs, from *within* this community?" Zuckerberg told her he planned to invest in the local schools and to make other contributions to the area. Elisa says she was satisfied. "As long as they stay conscious of not leaving out the little people from around here, then it will be okay. This," she says, "can only be a win-win situation."

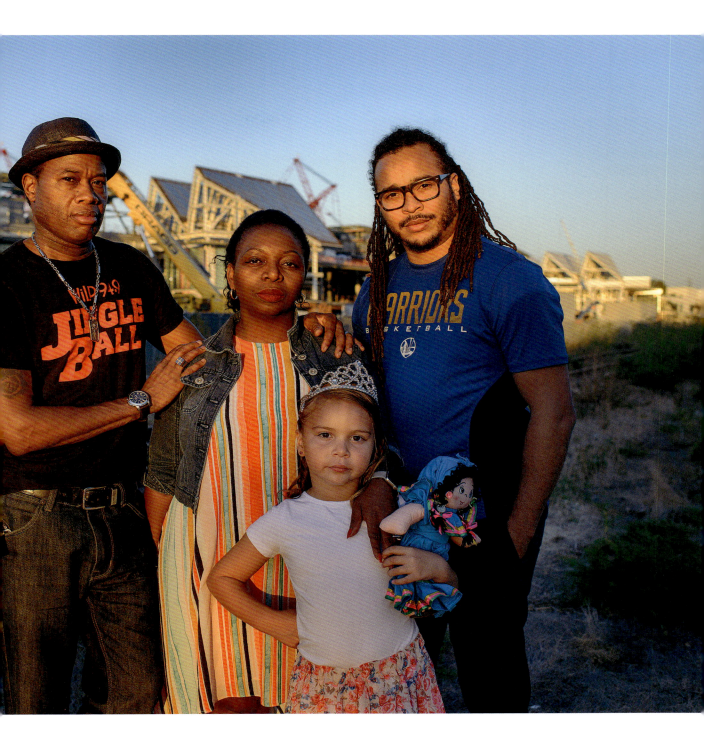

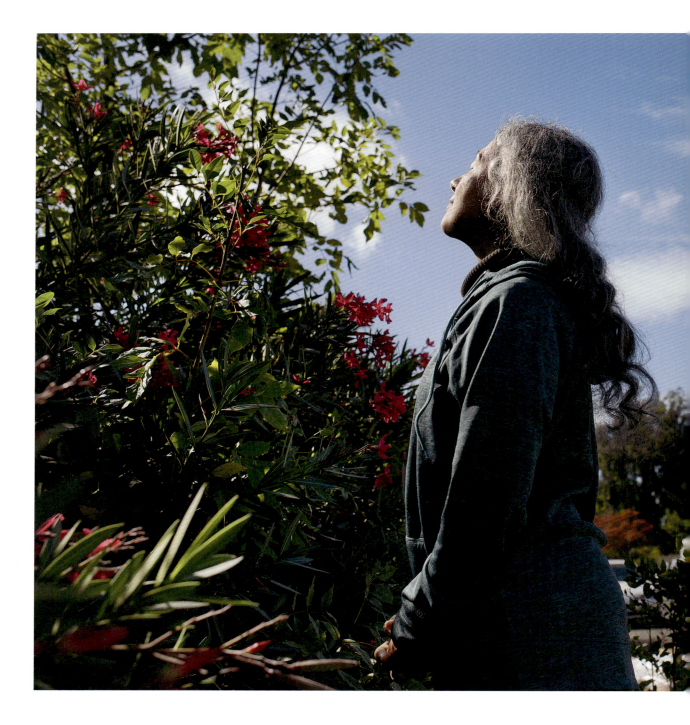

THE HOMELESSNESS
THAT WAS SUPPOSED TO
BE JUST A MONTH
STRETCHED INTO YEARS.

ELIZABETH

Elizabeth studied at Stanford and now works for a major tech firm. She is also homeless. Sitting on a panel at San Jose State University, she said, "Please remember that many of the homeless—and there are many more of us than are captured in the census—work in the same companies that you do. Something's happened in our lives—we've lost our houses, or we've had a medical catastrophe, or one of the people in our families lost their job—and without multiple incomes, we can't maintain the housing that we had. So, a lot of us work in the same companies that you do. Sometimes we work in the low-end jobs. Sometimes we're serving you food in the cafeteria, or sitting in the lobby, checking your badge when you come in. Sometimes we're going to be cleaning the floors when you leave.

"But other times we're in mid-level jobs. Some of us, believe it or not, were middle class until very recently, and we were living paycheck to paycheck. It is possible to have a mid-level salary and still be living paycheck to paycheck in Silicon Valley.

"Sometimes it takes only one mistake, one financial mistake, sometimes it takes just one medical catastrophe. Sometimes it takes one tiny little lapse in insurance—it can be a number of things. But the fact is that there's lots of middle-class people that fell into poverty very recently. And their homelessness that was just supposed to be a month or two months until they recovered, or three months, turns out to stretch into years. Please remember, there are a lot of us."

Afterword — *Mary Beth Meehan*

In October 2017 I moved into an Airbnb in Menlo Park, California. I wanted to explore and understand Silicon Valley on an intimate, human level and to convey a sense of what life was really like for people there.

For six weeks I did what I do for every project: I introduced myself to strangers, asked questions, and sat in kitchens and living rooms and restaurants, listening. The well-to-do professionals raising their families, the residents who've been there since before Facebook and Google set up shop, the workers on whose manual labor the technology industry depends —everyone had something to tell me about what it meant and how it felt to be living in Silicon Valley.

I was there at the invitation of Fred Turner, a professor at Stanford and longtime observer of Silicon Valley. He told me that he was troubled by the power of the region's mythology and wanted people to see the place as it is. He asked if I'd be willing to come and try to see it through my own eyes.

At first, Silicon Valley seemed as far from my roots as the surface of the moon. I grew up in the heart of industrial New England, in a shoe-factory town where my Italian grandmother assembled boxes. Her best friend worked as a maid for a leather-mill owner. They lived in their own houses, trimmed with lace curtains and painted shutters. My father, a firefighter, was the grandson of Irish immigrants; one of his best friends was a custodian at my high school.

Before I arrived in California, Fred had sent me articles and books that undercut the popular image

(previous spread) *Former landfill near Facebook headquarters, Menlo Park*

of Silicon Valley: *Behind the Silicon Curtain*, *The High Cost of High Tech*, *The Devil in Silicon Valley*. Once there, in my small rented room, I stuck orange notes above my desk to remind myself of my purpose: "What does it feel like to be you, here, in this moment?" said one; "Invisible Community, Invisible Relationships, Invisible Human Beings," said another. I'd get into my rental car early each morning and send out a wish to the universe: Let me meet who I'm supposed to meet. Let me hear what they have to tell me. From a party at a mansion inhabited by young tech stars, to a United Auto Workers union meeting, to a homeless encampment at the edge of San Jose, I began piecing together a narrative.

Once a week Fred and I would get together for dinner at his house in Mountain View. He and his wife, Annie, would prepare a big meal and pepper me with questions: "What are you seeing? What are you finding out there?"

I told them that what surprised me, and what stays with me still, was the unease that was palpable in Silicon Valley—in my conversations with people, but also on the faces of people on the streets, behind cash registers, serving in restaurants. From those at the lowest end of the economic spectrum to those with higher incomes whose unease was more existential, people conveyed how hard it was to find balance, connection, and community. The sense of distress was so pervasive that I wondered if I was seeing things correctly. A friend of mine in Berkeley, a journalist whose husband covers the technology industry, likened it to an American Third World: "This is the future," she said, "and it is a dystopia."

Every week, sitting under the redwood trees in his backyard, Fred and I would make lists of the themes we saw emerging and draw graphs to try to visualize this ecosystem—was it a pyramid, with Mark Zuckerberg at the top and all other workers down below? Or was it more like a globe, with Zuckerberg at the center, held in place by a web of workers supporting him? And how could we make sense of the disparities between the valley's extraordinary technological achievements and the anxieties I kept encountering?

In 2019 I went back to Silicon Valley to do a final bit of reporting. I contacted María Marroquín, the director of the Day Worker Center of Mountain View, who was one of the first people I'd met on my original trip. María had helped me understand the pressures on laborers in the valley and introduced me to the many working people who were homeless in Mountain View. When she walked into the restaurant, I was startled to see that the energetic woman I'd met two years before now looked tired, worn. The local city council had just passed a ban on overnight parking for RVs. This meant that the workers in Silicon Valley who'd cobbled together a semblance of home out of mobile vehicles would soon have to break those down and begin again. People's meager resources were fraying, she said, and they were afraid. Things were getting worse.

Back in 2017 I never imagined I'd make a connection between my grandmother assembling shoeboxes in Massachusetts and the high-tech engineers of Silicon Valley. Yet, I found myself asking how it was that a twentieth-century factory town could provide more security for my grandmother than this twenty-first-century center of wealth and innovation was offering many of its workers. If my grandmother had been working in Silicon Valley, I realized, she might never have had a home at all.

Acknowledgments

We could not have created this book without the help and encouragement of many people. First and foremost, we would like to thank those who have so graciously allowed us to talk with them and photograph their lives. We're deeply grateful for everything they've taught us about Silicon Valley. We would like to thank the Knut and Alice Wallenberg Foundation, the Stanford Arts Initiative, and especially Matthew Tiews, Stanford's Associate Vice President for Campus Engagement, for making Mary Beth's residency at Stanford in the fall of 2017 possible. We're grateful to Stanford's Departments of Communication and Art and Art History for supporting Mary Beth's work during her stay. We would especially like to thank Lisa and Peter Cirenza, whose generous and timely gift has helped bring this book into being. Geri Migielicz gave us exceptionally good guidance as the work was coming together, and Elodie Mailliet Storm of Getty Images introduced us to each other and helped shape our early thinking about what seeing the valley might mean. We thank them both. We would also like to thank Jenny Reardon, professor of sociology and founding director of the Science and Justice Research Center at the University of California, Santa Cruz; Morgan Ames of the University of California, Berkeley; Joseph Klett,

from Philadelphia's Science History Institute; and Jan English-Lueck, professor of anthropology at San Jose State University, for helping us think through what it means to visualize social and technological change in this region.

We thank Mary Beth's generous supporters who have helped make this book possible: Nancy and Edward Meehan, the Gabriel family, the Martel family, Maria DeCarvalho, Kristan Diefenbach and Jim Kravets, Sheila Bonde, Jane Desforges, Len and June Newman, Mindy and Jim Oswald, and Amy and John Simpson. And we thank the colleagues who were always happy to answer her questions: Carolyn Drake, Andres Gonzalez, Phuong Ly, and Richard Renaldi.

There are many people at work on the ground in Silicon Valley who are tireless in their efforts to understand and improve people's lives. We thank them for the time they spent with Mary Beth, helping her to meet people and understand the place while she was here. They include Rebeca Armendariz, Alejandra Domenzain, Marina Gorbis, Amanda Hawes, María Marroquín, Susan Reed, Lenny Siegel, Ruth Silver Taube, and Dave Watermulder, among many others.

A book is only as good as the team that helps produce it, and we have been blessed in this department. We are especially grateful to Hervé Le Crosnier and Nicolas Taffin at C&F Éditions. Their early faith in the project brought it to life; without them, what you're looking at would not exist. The same can be said of our American editor, the incomparable Joe Calamia. He has followed this project from early on and has made it better every step of the way. Emma Sampson's technical assistance and expert printmaking were invaluable as the work progressed.

Mary Beth's decades-long friendships in the business of storytelling helped nurture this book to completion. We are grateful to Hilary Horton for her incisive editing, Michele McDonald for her beautiful eye for photographs, John Freidah for his big-picture insights, and Beth Nakamura and Lois Raimondo for reminding Mary Beth never to forget about Brockton. And to Lucinda Hitchcock, for her brilliant book design, we are thankful.

Finally, we would like to thank our extended families. In Providence, to Chad Galts for his deep love and keen editing, to Nancy Meehan for her steadfast support, to Graham and Edward for taking on more so Mary Beth could do her work, and to Kate Lacouture and friends who supported her family while Mary Beth was away, we extend our deepest thanks. And to Annie Fischer in Mountain View, who encouraged Fred to pursue this project with abandon, we are ever grateful.

Mary Beth Meehan is a photographer known for her large-scale community-based portraiture. For the past twenty-five years, she has focused on questions of representation, visibility, and social equity, embedding herself in towns and cities from postindustrial New England to the American South, as well as Silicon Valley. She lives in New England.

Fred Turner is Harry and Norman Chandler Professor of Communication at Stanford University. He has studied Silicon Valley culture for twenty years and is the author of the widely acclaimed history *From Counterculture to Cyberculture: Stewart Brand, the Whole Earth Network, and the Rise of Digital Utopianism*, among other books.